ART DECO

FLIGHTS OF ARTISTIC FANCY

Susan A. Sternau

NEW LINE BOOKS

Fax: (888) 719-7723
e-mail: info@newlinebooks.com

Printed and bound in Singapore

ISBN 1-59764-075-1

Visit us on the web!
www.newlinebooks.com

Author: Susan A. Sternau

Publisher: Robert M. Tod
Editorial Director: Elizabeth Loonan
Book Designer: Mark Weinberg
Senior Editor: Cynthia Sternau
Project Editor: Ann Kirby
Photo Editor: Edward Douglas
Picture Reseachers: Heather Weigel, Laura Wyss
Production Coordinator: Annie Kaufmann
Desktop Associate: Paul Kachur
Typesetting: Command-O

Picture Credits

CONTENTS

INTRODUCTION

Developed in Paris and later promoted in Hollywood as the style of the stars, Art Deco made the transition, in a few short years, from a primarily French style to a universally understood symbol of glamour. Art Deco, a convenient term used to describe decorative art in the period between the two world wars, refers to a style that is classical, symmetrical, and rectilinear. As a movement it developed during the years 1908 to 1912 and reached a high point from 1925 to 1935. This style was the product of influences as diverse as Art Nouveau, Cubism, the Bauhaus, and the arts of Egypt, the Orient, Africa, and the Americas.

Art Deco began as a light, graceful innovation inspired by the Russian Ballet, but soon evolved to reflect the stark simplicity and austerity of modern life in the machine age. Modern artists in all aspects of the fine and decorative arts sought to express the speed and intensity with which the car, train, airplane, radio, and electricity were transforming their world—using colors and forms that were purer, bolder, and more intense than they had previously employed. First recognized as a style in Europe, Art Deco soon became immensely popular in the United States, very much popularized as well by the look and image of Hollywood movies. The costumes and props of Paramount's *Cleopatra* (1934), for example, make clear references to the ornaments and gargoyles of New York's new Art Deco skyscraper, the Chrysler Building, while actress Greta Garbo's costume in MGM's *Mata Hari* (1932) makes her look exactly like a bronze and ivory Art Deco statuette.

The term "Art Deco" stands for the Exposition Internationale des Arts Décoratifs et Industriels Modernes ("International Exposition of Modern Decorative and Industrial Arts"), a comprehensive exhibition of applied arts held in Paris in 1925. The term itself is even newer—it was coined when Paris held a revival of that exhibition in 1966 at the Musée des Arts Décoratifs ("Museum of Decorative Arts"). This exhibition signaled a renewed interest in the

Nymph and Hind

MARIE LAURENCIN, 1925; oil on canvas; 71 x 52 cm. (180.3 x 132 cm).
Gift of Mr. & Mrs. Herbert Cameron Morris, The Philadelphia Museum of Art.
A quintessential Art Deco painter, Laurencin worked in an accessible
and fashionable style that was popular with the public. Her costume
and set designs for the Russian Ballet were an unqualified success.

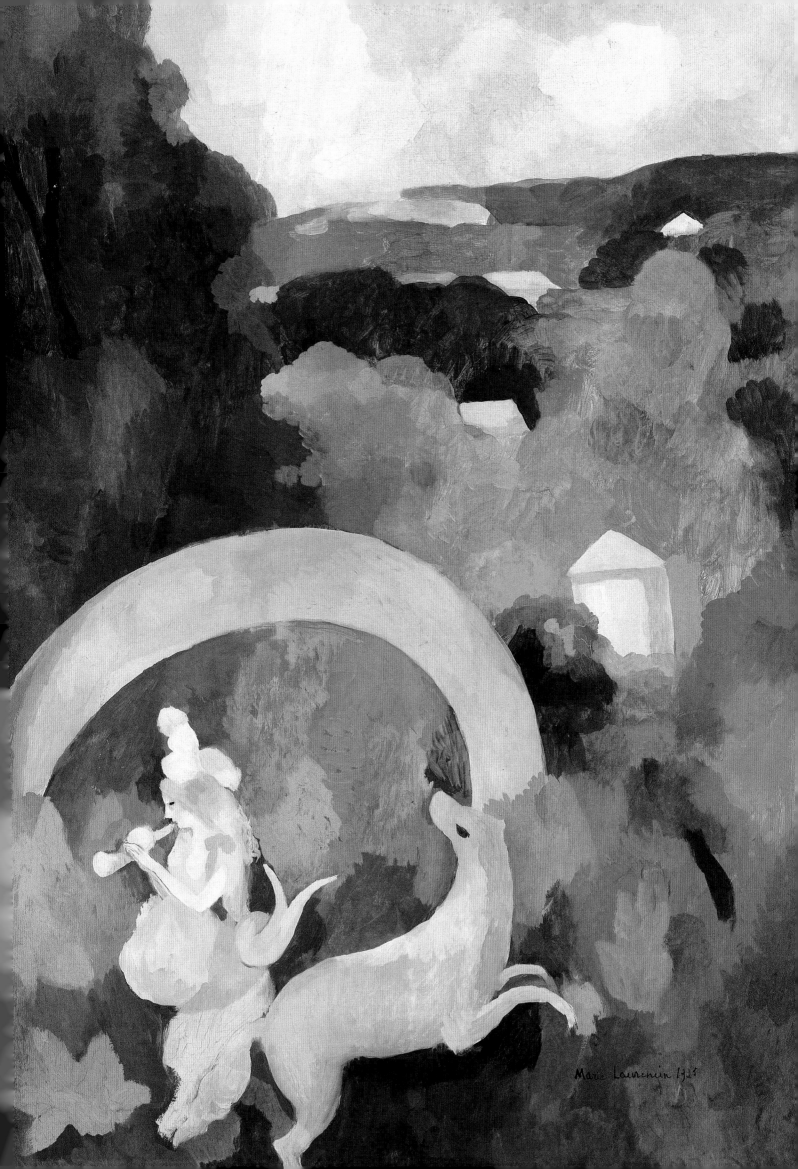

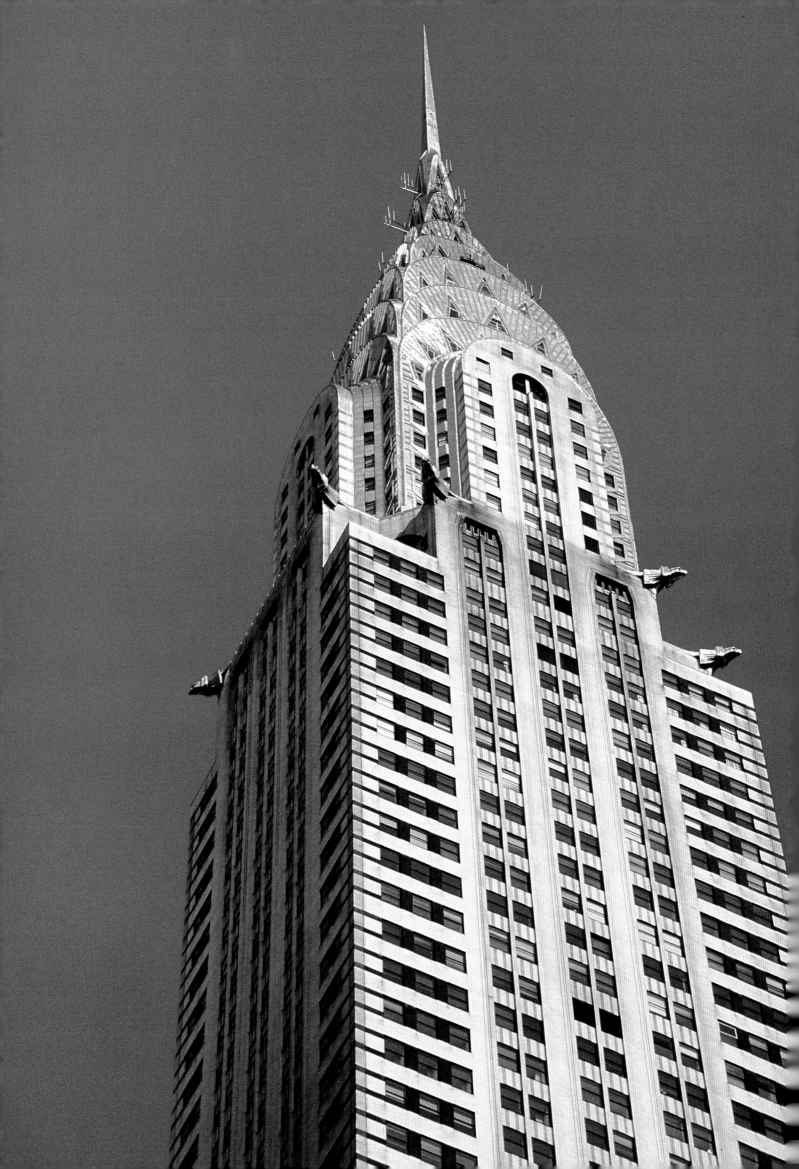

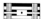

decorative arts of the period, which although hailed as the "Moderne" style of the time had, in the nature of the development of styles, been superseded by the even more popular and universal International style—an ornament-free architecture characterized by the expression of structure and mass enclosing dynamic space. Art Deco was also variously known as Jazz Moderne, Zigzag Moderne, and later Streamline Moderne—this last a reference to forms based on the aerodynamic curves of cars, boats, and planes.

Art Deco pervaded modern life in the interwar years. It shaped the way people dressed, the way they communicated, the way they traveled, and the way they worked and spent their leisure time. It influenced entertainment and modern culture—its reach was felt in movie palaces, apartment buildings, skyscrapers, interior furnishings, jewelry, smoking and drinking accessories, tableware, lighting, sculpture, posters, magazine and book illustration, fabrics, painting, and public works and buildings of all descriptions. Bridges, tunnels, gas stations, fast food restaurants, and that inimitable fixture of modern life, the neon sign, were

all created in the "Moderne," or Art Deco style. Schools, courthouses, stores, federal buildings, and World's Fair pavilions were built in the style which was at once neoclassical and streamlined, graceful and playful, monumental and elegant.

People everywhere went to the movies in Art Deco theaters fashioned with elaborate facades, bright neon lights, and sleek interiors. In New York City, the stylized ornament of entryways, the neoclassical sculptures of Rockefeller Center, the arched spire of the Chrysler Building, the distinctive tower of the Empire State Building, and the sculpted aluminum ornaments adorning the doorways and light fixtures of residential buildings created an environment that was both accessible and extraordinary.

Today, Art Deco societies in many cities are working to preserve the Deco legacy, but the most enduring presence of Art Deco architecture without doubt is the great movie theaters, with their grandiose facades and fanciful neon signs, a reminder that Art Deco, at its best and most visible, was both a public and a theatrical style.

The Chrysler Building

WILLIAM VAN ALEN, 1930. New York City.
An arched spire sheathed in stainless steel and
punctuated with triangular windows gives this well-
known skyscraper a highly dramatic appearance.

The Scottish Musical Review

CHARLES RENNIE MACKINTOSH, 1896;
poster; 97 x 39 in. (246.3 x 99 cm).
The Museum of Modern Art, New York.
An example of the "severe" side of
Art Nouveau, works such as this poster
by Glasgow artist and architect
C. R. Mackintosh were a factor in
the development of the Art Deco style.
Exaggeration, stylization, and an
interest in geometrical shapes
reduce the subject—a woman with
birds—to a semi-abstract design.

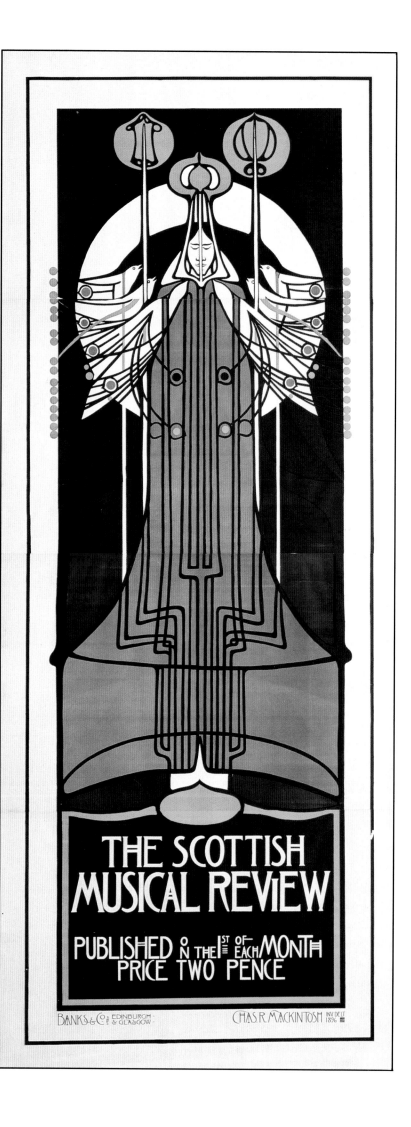

TOWARD A MODERNE STYLE

The twentieth century burst forth with many innovations in art, literature, and music. The machine was quickly gaining preeminence, and the First World War altered forever the fabric and values of society. The twenties brought the Jazz Age, a time of recklessness and experimentation, of opulent living for some, and hardship following the war for others. Germany not only fledged its own influential design movement, the Bauhaus, it also gave rise to the Nazis and nurtured anti-Semitism and intolerance. When the aggressions began that gave rise to the Second World War, many talented European designers emigrated to the United States, bringing their ideas and skills with them, and stirring America into a new period of innovation in the decorative arts and architecture.

SOURCES OF ART DECO

Art Deco evolved out of many currents in art and design around 1900, including Art Nouveau, the Vienna Secession, the German design associations known as Werkbunds, Russian Constructivism, and the Dutch De Stijl movement. Art Deco also would not have evolved if the style had not been able to draw on revolutionary modern movements in painting such as Abstraction and Cubism.

In 1900 the dominant style was Art Nouveau, an exuberant curvilinear style which had already pioneered concepts of pictorial flatness and stylization that Art Deco was to take many steps further. The baroque, exaggerated curves of Art Nouveau, however, were less influential to the development of Art Deco than the so-called severe side of Art Nouveau, as seen in the work of the Scottish architect and designer Charles Rennie Mackintosh of the Glasgow School. Mackintosh's poster for *The Scottish Musical Review* is both flatly geometric and stylized. The figure is absurdly tall, and re-

duced to an almost abstract maze of parallel lines. The geometric nature of Mackintosh's designs, as well as those of the other artists of the Glasgow School, had a profound impact on the development of the style of the Vienna Secession artists—another group of young artists in opposition to the norm whose geometric style inspired Art Deco. The style of the Vienna Secession (founded in 1897) was elegant, decorative, and functional; the Secession artists—among them Josef Hoffmann, Gustav Klimt, Joseph Maria Olbrich, and Solomon Moser—generally preferred squares and rectangles in decoration. The curves and clean lines of a

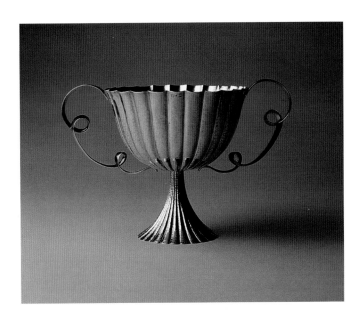

Bowl

JOSEF HOFFMANN, c. 1920; silver; 7½ x 11⅜ in. (19.1 x 29.2 cm). Gift of Jennifer Johnson Gregg, 1976, The Metropolitan Museum of Art, New York. Hoffmann, a founder of the Vienna Secession, designed this silver bowl to be elegant and graceful. Hoffmann was an innovative architect but his handling of silver is more conservative than his buildings, which include the influential Stoclet Palace in Brussels.

silver bowl designed by Hoffmann give a sense of the graceful elegance of his design.

As early as 1907, the German design associations known as Werkbunds had promoted a link between the arts, industry, and progressive architecture. Such a linkage was an innovative idea for its time. It had important implications for Art Deco, as well, for without the broad application of design principles this connection allowed, Deco would never have achieved such widespread visibility and popularity. Stylistically, the Werkbunds carried on the tradition of logic and geometry found in the Glasgow School and the Vienna Secession style. Werkbunds emphasized functional design, which could be applied to mass production but was also aesthetically pleasing. Ornament was accorded a secondary status, a philosophy which was later upheld by the German Bauhaus, a design center formed in 1919.

The underlying principles of the Glasgow School, the Vienna Secession, and the German Werkbunds were all founded on the idea of unity in art and design put forth by William Morris, leader of the English Arts and Crafts movement. Taking Morris' principles even further into the new century, the Bauhaus designers, led by Walter Gropius, proposed that the forms of inexpensive, mass-produced objects should reflect their function, materials, and manufacture. Ornament derived from previous styles compromised the purity of design and luxuries were considered socially irresponsible. Art Deco, however, began by reveling in luxuries and ornament. Only later did it move in the direction of functional design pioneered by the Bauhaus, when Bauhaus designers fleeing persecution in Germany brought their ideas to the American Art Deco movement.

RUSSIAN INFLUENCES

The Art Deco style did not spring from one source but was rather the product of the commingling of many ideas that were developing almost simultaneously at this time, as well as an interest in the native and folk art traditions of many cultures. Russian art movements, which looked both forward and backward for ideas, were one important source of the Art Deco style. Revolutionary politics made for revolutionary art as well—Mikhail Larionov and his pupil and friend Natalia Goncharova explored the expressive potentials of Russian icon painting and children's art, as well as a style known as Rayonism, which based paintings on the patterns of intersecting and dissolving light rays. Kasimir Malevich, another Russian painter, developed Suprematism, in which he reduced painting to one white square superimposed upon another. With the Russian Revolution of 1917, Contructivism was briefly the favored style, and was to have a lasting impact on Western art. Constructivism was based on the belief that art has a social purpose, and also on the view that art is a personal rather than a public experience. Constructivist artists produced works which were constructions of geometric forms that look like machinery, and used lettering in new ways that influenced the graphic work of Art Deco.

DE STIJL

The simple, geometric style developed by Dutch artists of the De Stijl movement also contributed to the look of Art Deco. Dutch artists at this time were also searching for a new style appropriate for every aspect of contemporary life—a style that would embrace all design in a universal intellectual and visual harmony. By rigorously analyzing the primary elements of artistic structure and expression, De Stijl artists, such as Piet Mondrian and Theo van Doesburg, arrived at a vigorously geometrical style characterized by rectangles of color held into the picture plane with a grid of dark lines.

Although De Stijl artists were excluded from the seminal 1925 Exposition of Decorative Arts in Paris, the influence of their style was evident in one of the most striking structures, the Pavilion of Tourism, designed by Robert Mallet-Stevens. Mallet-Stevens'

Pavilion of Tourism

ROBERT MALLET-STEVENS, *1924–25; perspective drawing; Musée des Arts Décoratifs, Paris.*
Constructed for the 1925 Paris International Exposition of Decorative Arts, this pavilion was designed to show the potential of a building material new to the era—reinforced concrete. Parallel and intersecting slabs of concrete create a dramatic structure that owes a debt to the Dutch design movement, De Stijl.

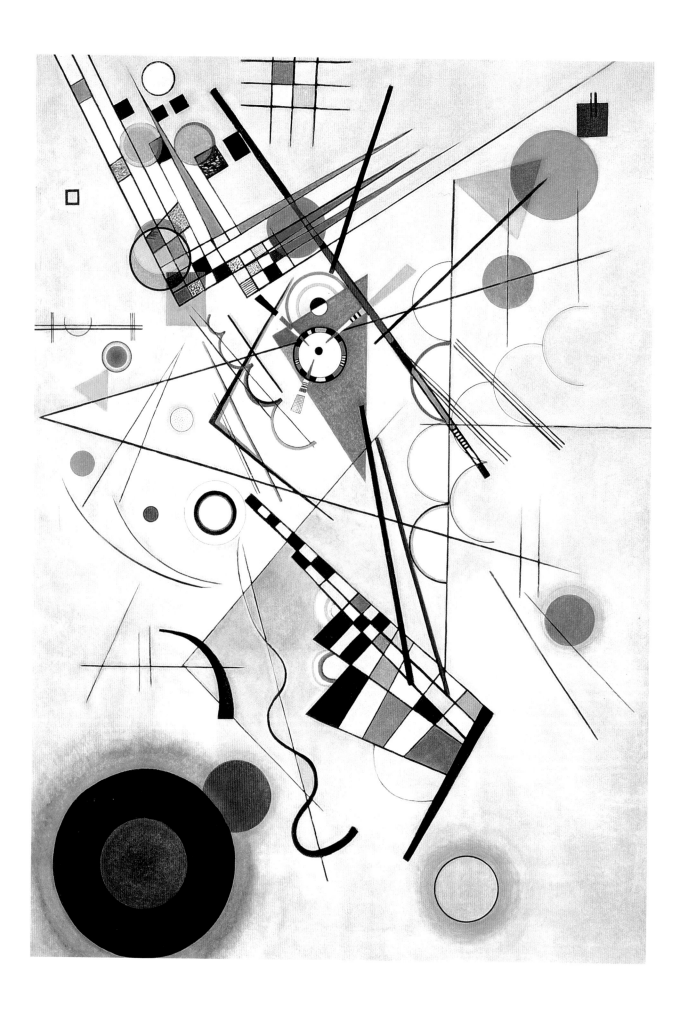

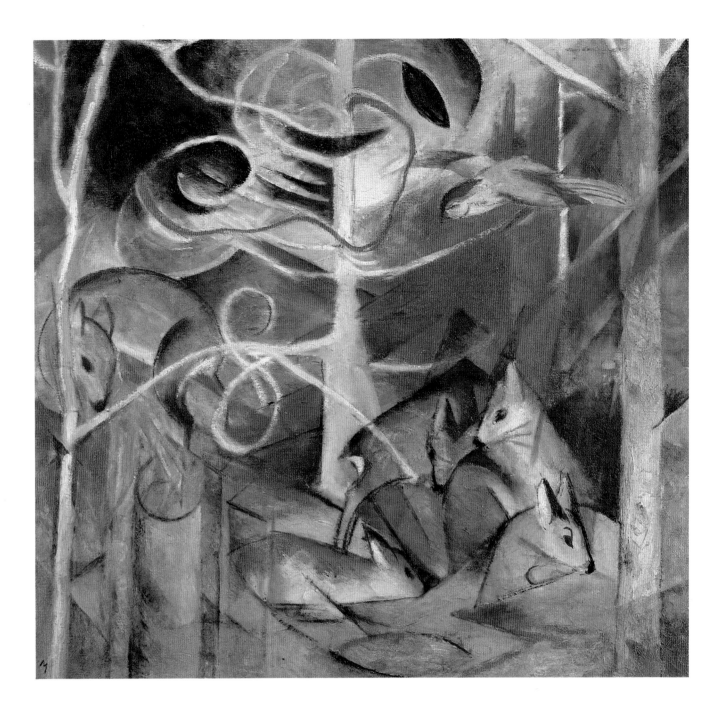

Composition 8, No. 260

WASSILY KANDINSKY, 1923; oil on canvas; 55 x 79⅛ in.
(139.7 x 200.9 cm). The Solomon R. Guggenheim Museum, New York.
Credited with the development of abstraction in art,
Kandinsky here works in a precise, geometrical style, com-
bining colorful and simple shapes such as circles, squares, and
triangles with simple black lines against a light background.

Deer in the Wood, No. I

FRANZ MARC, 1913; oil on canvas; 39 x 41 in.
(99 x 104.1 cm). Phillips Collection, Washington, D.C.
Marc believed that animals were more spiritual and beautiful
than humans, and in his paintings he sought to express this belief
by painting animals in their natural environment. But he did
so with symbolic colors not appearing in nature and with frag-
mented Cubist planes that express a heightened emotional state.

pavilion was one of only a few aggressively "modern" designs in the sense of International modern style (not Art Deco "Moderne") at the Exposition. It was designed to show the expressive potential of building with a modern material—in this case, reinforced concrete. The slender clock tower of the pavilion was constructed of two thin intersecting slabs of concrete, while the square entrance was balanced by three horizontal concrete slabs in a simple and expressive use of planes and rectangles.

Other pavilions at the 1925 Paris Exposition, such as the Maîtrise Pavilion, the Primavera Pavilion, and the Pomone Pavilion, were more united in what has come to be recognized as the Art Deco style than Mallet-Stevens' Pavilion of Tourism. For these pavilions were widely imitated by Art Deco architects, while Mallet-Stevens' pavilion was not. The Maîtrise, Primavera, and Pomone Pavilions were visually distinguished by their neoclassical columns, stepped terracing, monumental entrances, and vast areas of flat stylized decoration. Their grand "Exposition style" became a model for the public face of Art Deco architecture.

ABSTRACTION

The development of Abstraction in Western art, yet another early twentieth-century art phenomenon, contributed to the formation of Art Deco. The Abstraction innovation is generally credited to Russian artist Wassily Kandinsky, who lived and work in Munich, Germany, from 1896 to 1914. Kandinsky gradually eliminated the subject from his paintings until they were entirely abstract. Kandinsky's first abstractions, such as his *Composition 8, No. 260*, became, by the early twenties, a sensitive balance of colorful geometrical forms, articulated by black lines and elegantly placed against a light background.

The expression of rapid movement with speed lines and repeated forms was to become a favorite motif of Art Deco. The German painter Franz Marc experimented with expressing fast violent movement in his paintings of animals through a combination of bright color, repetition, and abstract lines and planes. His

painting, *Deer in the Wood, No. I*, shows his interest in breaking down the image visually in order to show movement. Marc also shared with Kandinsky a quest for the spiritual in art, although such profound explorations were foreign to Art Deco—a style concerned primarily with appearance.

The American trend toward abstraction can be seen in the stained-glass windows that influential architect Frank Lloyd Wright designed for the Avery Coonley Playhouse in Riverside, Illinois. These tasteful, geometrically patterned windows feature a design of playfully bright circles and squares of color that contrast beautifully with the linear patterns of the leading.

CUBISM

Although many factors in various countries clearly contributed to its evolution, the birth of the Art Deco style has been rightly credited to France. The stylistic synthesis that evolved into Art Deco had coalesced into a recognizable style by the time of the 1925 Paris International Exposition of Decorative Arts.

Cubism was the art movement with by far the most universal influence on Art Deco because of the way it broke down and analyzed the geometric qualities of its subjects. Paintings from the first phase of the movement, known as "analytic" Cubism, were generally monochromatic and reduced the subject to a grouping of shifting interwoven planes. The Cubist vision emerged in the work of Pablo Picasso and Georges Braque around 1908–09. Georges Braque's *Harbor in Normandy* is an example of this Analytic phase of Cubism. According to art historian George Heard Hamilton, Braque "reduced forms to 'little cubes' and then by shifting their axes broke the angular connections and released new, non-

Harbor in Normandy

GEORGES BRAQUE, 1909; oil on canvas; 31³/₈ x 31³/₈ in. (81 x 81 cm). Samuel A. Marx Purchase Fund, The Art Institute of Chicago. Braque, a very innovative Cubist painter, presents a whole new concept of space with the fragmented planes and shaded facets of this seaside scene he painted from memory. Braque wanted to create a work that expressed his desire to touch things, not merely to see them.

Stained-Glass Window for the Avery Coonley Playhouse, Riverside, Illinois

FRANK LLOYD WRIGHT, 1912; glass, lead, and wood; 86 in. high (218.4 cm). Purchase 1967, Edward C. Moore, Jr., gift, and Edgar J. Kaufmann Charitable Trust Fund, The Metropolitan Museum of Art, New York. Influential American architect Frank Lloyd Wright sometimes called these windows his "children's symphony" because the brightly colored circles suggest balloons. The elegant geometry Wright employed was extremely innovative for his time.

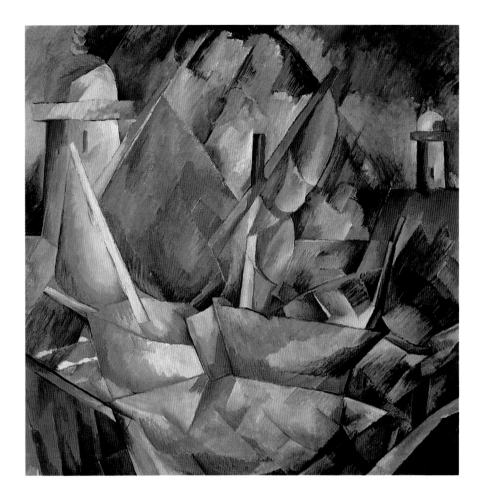

naturalistic, pictorial rhythms." Art Deco was profoundly influenced by the Cubist treatment of planes, and also by the Cubist use of color.

Picasso's *The Three Musicians* represents the second, or "synthetic," phase of Cubism. The complex design techniques used here include both a construction of forms which are independent of the subject and many degrees of depth created by overlapping planes. Synthetic Cubist compositions often used collage, known as *papiers collés*, and illusionistic painting techniques, known as *trompe l'oeil*, which added texture, complexity, and variety. Both of these techniques were inspirational to Art Deco artists.

Another variation on Cubism, Orphic Cubism (1900–14), as exemplified by *The Eiffel Tower* by Robert Delaunay, also had implications for the development of Art Deco. Delaunay enjoyed portraying the dynamism of city life. The Eiffel Tower was a symbol of modernity for Paris, much the way the skyscraper was soon to become a symbol of modernity in New York City. Delaunay also painted height, speed, and prismatically bright colors. He was the husband of Russian artist Sonia (Terk) Delaunay, who also worked with similar color theories, creating strikingly avant-garde paintings as well as modernistic textiles and tapestries.

In addition, the visual impact of French painter Fernand Léger's works speak clearly of the machine aesthetic. The human form, interiors, cityscapes—all are fashioned into strongly cylindrical, tubular shapes that suggest the pipes and fittings of machinery. Léger created symbols for the modern means of life, icons of a mass-produced, machine-dominated environment that modern living encompassed—a style which Art Deco artists embraced.

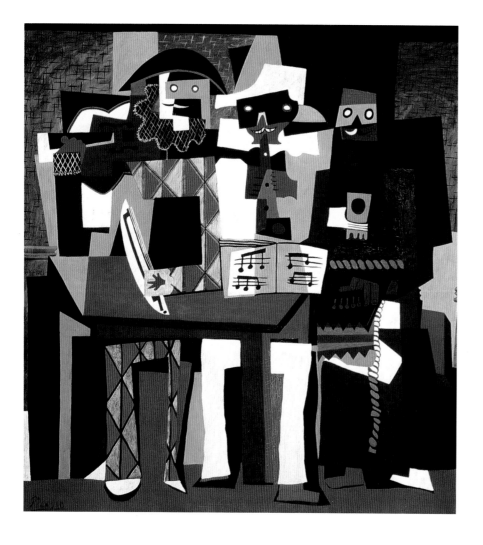

The Three Musicians

*PABLO PICASSO, 1921; oil on canvas;
80 x 74 in. (203.2 x 187.9 cm).
The A. E. Gallatin Collection,
The Philadelphia Museum of Art.*
The brilliant colors of these musicians' costumes against the dark background create a sense of mystery, while their masks seem to conceal a threat. The synthetic Cubist style developed by Picasso also had a jazzy, flat decorative quality and innovative use of texture that was adapted by Art Deco artists and designers.

The Eiffel Tower

*ROBERT DELAUNAY, 1910; oil on canvas;
79 x 54 in. (200.6 x 137.1 cm).
The Solomon R. Guggenheim Museum, New York.*
Delaunay's Orphic Cubism was a product of his wish to create effects of recession and movement in space exclusively through color contrasts. The Eiffel Tower, erected in 1888, was to Paris a symbol of modernity the way the skyscraper was to Manhattan.

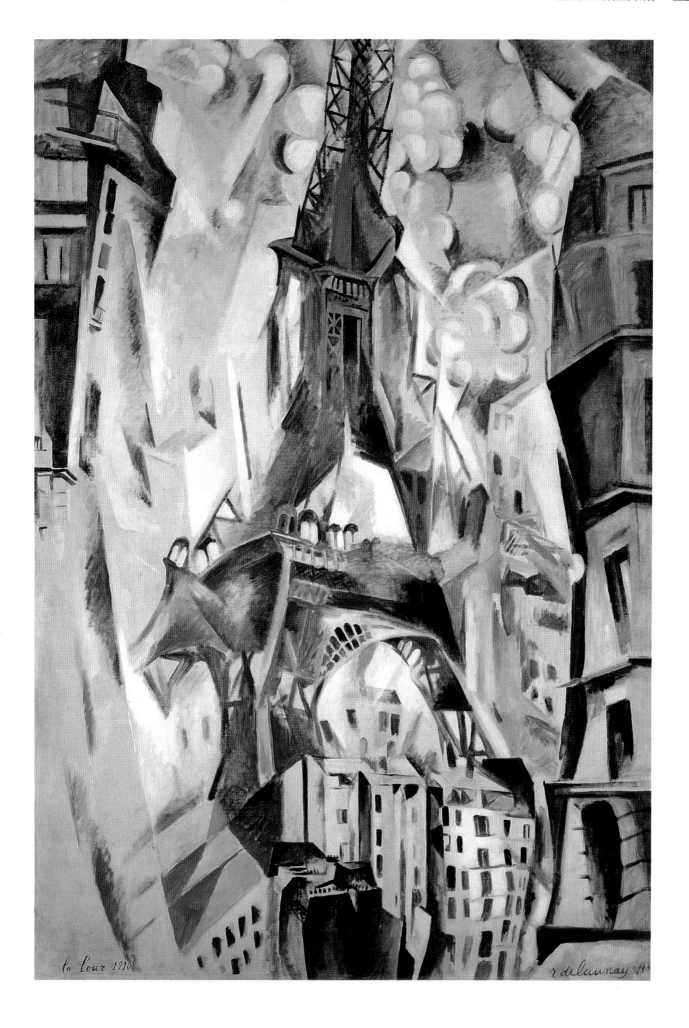

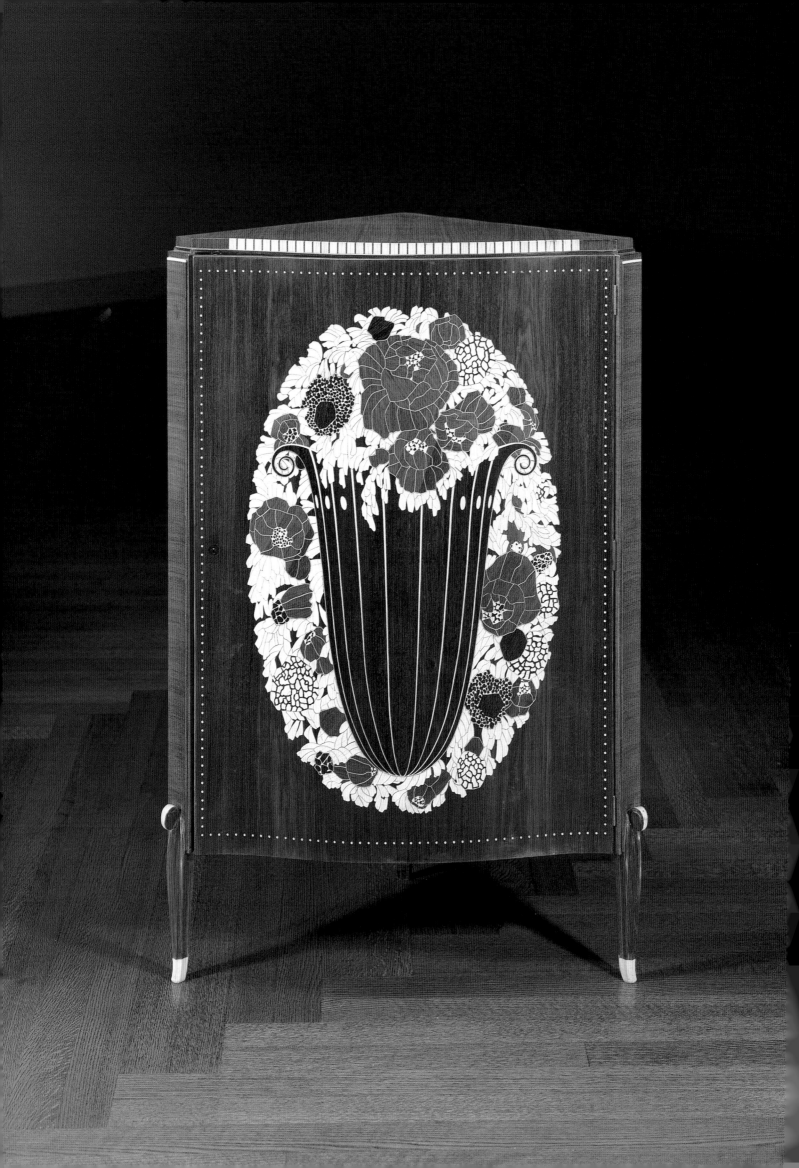

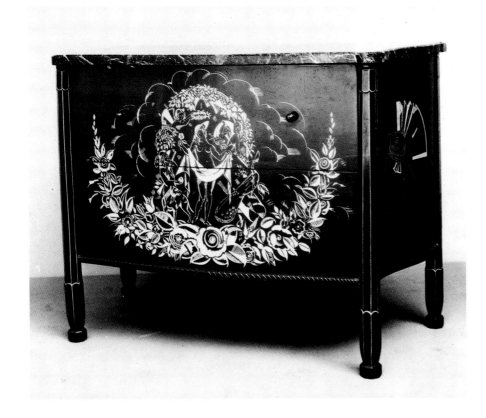

Commode

*SÜE ET MARE, design, with
decoration by PAUL VÉRA, c. 1920.
Edward C. Moore, Jr., gift fund,
1923, The Metropolitan
Museum of Art, New York.*
The partners Louis Süe and
André Mare designed interiors
and many types of decorative ob-
jects. Their traditionalist Art Deco
furniture was inspired by the Louis
Philippe period—it was gracefully
curved and decorated with lacquer,
veneer, and carved wood details.

FINE FURNITURE

France also was home to a number of fine furniture
workshops, which drew upon a cabinet-making her-
itage of the late eighteenth and early nineteenth cen-
turies as a point of departure for a new style when the
excesses of Art Nouveau furniture became passé.
Emile-Jacques Ruhlmann counted among the finest of
these furniture makers. The refined simplicity of his
corner cabinet is characteristic of his production—the
cabinet door is veneered with a stylized basket-of-
flowers motif, variations of which were widely used in
Art Deco. Ruhlmann debuted at the Autumn Salon in
Paris of 1913 and produced masterpieces of cabinet-
work throughout the war years. His work is considered
an epitome of the Art Deco style. Ruhlmann gained an
international reputation at the 1925 Exposition—over
100,000 visitors came to see his Hôtel du Collec-
tionneur ("Collector's House") Pavilion.

Other names in traditionally inspired French Art
Deco furniture were Maurice Dufrène, Paul Follot,
Jules Leleu, Léon-Albert Jallot, Dominique, and
Louis Süe and André Mare—partners known collec-
tively as Süe et Mare. Süe et Mare's furniture was in-
spired by the Louis Philippe period. Gently curved
and elegantly decorated with lacquer, veneer, and
carved wood details, their work was at once sleek yet
luxurious and inviting. Süe et Mare became partners in
1919 and remained in business together until 1928.
They believed they were creating not only fashionable
objects but works of art bound to a magnificent past.

Corner Cabinet

EMILE-JACQUES RUHLMANN, 1916; palisander, Macassar ebony, and ivory.

Gift of Sydney and Frances Lewis, Virginia Museum of Fine Arts, Richmond, Virginia.

Fine workmanship, materials, and graceful styling distinguish the work of this French traditionalist Art Deco

cabinetmaker par excellence. The cabinet is decorated with a basket of stylized flowers, a popular early Art Deco motif.

Advance Fall Fashions

ERTÉ, September 1921. Cover of Harper's Bazaar.
Erté's elegant stylized figures have remained a staple of his
work for some sixty years. Inspired by the vibrant colors and
exotic Orientalism of Sergei Diaghilev's Russian Ballet, Erté
captured a light-hearted Deco spirit in his lively illustrations.

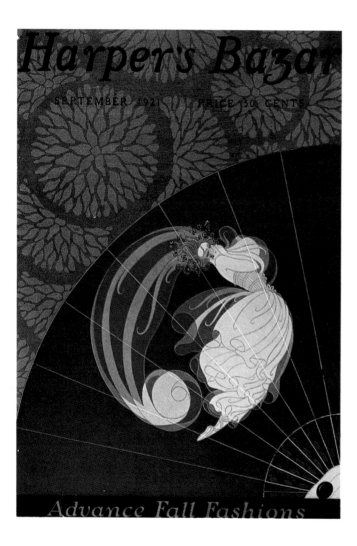

COSTUME AND SET DESIGN

Another source of inspiration for Art Deco were the
bright colors and exotic Persian and Oriental motifs of
Russian impresario Sergei Diaghilev's Russian Ballet,
which first opened in Paris in 1909. The costume and
scenery designs by Léon Bakst and Alexandre Bénois
rivaled in brightness the paintings of the Fauves, a
group of artists who had first exhibited in Paris in
1905. Bright oranges and blues, chrome yellow, hot
pink, lavender, and lime-green were suddenly the fash-

ion, seen in textiles, clothing, jewelry, and every type
of decoration as an aesthetic of "color for the sake of
color" emerged.

In 1912 *Afternoon of a Faun*—set to music by Claude
Debussy and with Léon Bakst's sets and costumes and
Vaslav Nijinsky's dancing—electrified audiences. The
following year, a production of *The Rite of Spring* cre-
ated a sensation and ushered in the era of modern
music with the startling novelty of Igor Stravinsky's
jagged rhythms, dissonance, and primitive quality. In
addition to introducing the Parisian public to modern
music, the Russian Ballet initiated them into modern
art movements—for after 1917 many avant-garde
artists, including Natalia Goncharova, Henri Matisse,
Pablo Picasso, Juan Gris, Robert Delaunay, André
Derain, and Marie Laurencin, were commissioned by
Diaghilev to design sets and costumes for his produc-
tions. For example, the Diaghilev company produc-
tion of *Les Biches* ("The Hinds") debuted in 1924 with
scenery and costumes by Marie Laurencin. The light,
graceful style of Laurencin's designs were very influ-
ential on Art Deco fashions. Her work mirrored the
fashionable, fanciful side of modern Parisian life with
a freshness and originality that caused *Les Biches* to be
received by the public with open arms. Diaghilev was
not the only ballet impresario to make use of the tal-
ents of avant-garde artists; Rolf de Maré's Swedish
Ballet employed Léger to design striking sets and cos-
tumes for the 1923 production of *La Création du monde*
("The Creation of the World"), which drew inspira-
tion from African tribal art.

Erté, the quintessential Art Deco designer and illus-
trator, was also inspired by the Russian Ballet. His so-
phisticated and highly stylized designs, such as his
fashion sketches for French designer Paul Poiret and
the many magazine covers he created for *Harper's
Bazaar*, sustained over some sixty years the lightness
and exuberance of the ballet experience. Erté was still
active during the Art Deco revival of the 1960s and
1970s, and because he had retained his singular style,
was able to provide Art Deco works to fill the renewed
demand.

The celebrated Parisian couturier Paul Poiret did
much to promote the exotic and colorful Art Deco

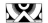

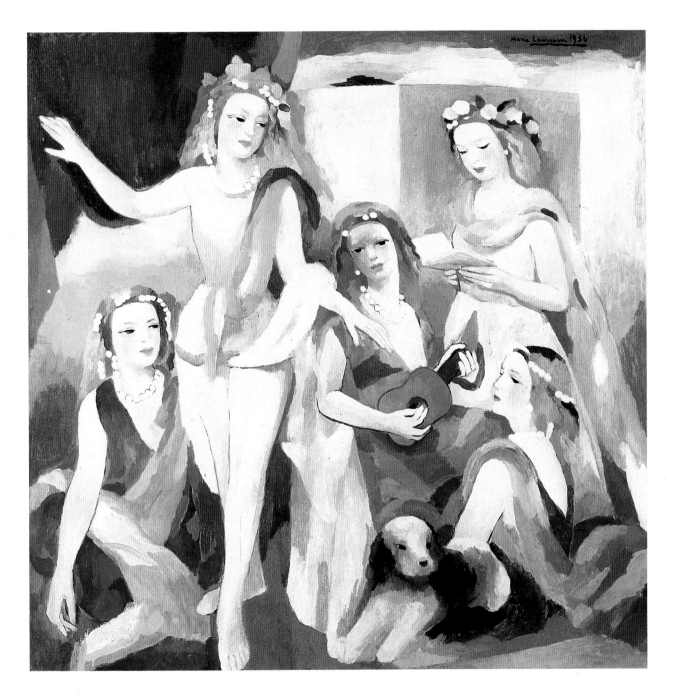

style that had been inspired by the Russian Ballet. He employed some of the best graphic artists of the day to bring his designs to life, among them Georges Lepape, who went on to become a prolific Art Deco illustrator. Poiret also had a shop, Maison Martine, which promoted a colorful and frivolous style. Many of his most successful designs, translated into fabric by Paul Dumas and carpet by the firm of Fenaille, had originated as student sketches by young girls at his Ecole Martine, a school he funded specifically to utilize the talents of these children. Poiret also employed Raoul Dufy, who went on to become a well-known painter in his own right.

The Rehearsal (La Répétition)

MARIE LAURENCIN, 1936; oil on canvas.
Musée National d'Art Moderne, Paris.
Laurencin's graceful figures are painted in a style that borrows from the most decorative aspects of the works of Picasso and Matisse. Women were her favorite subject for paintings, followed by floral still lifes.

Dynamic Hieroglyphic of the Bal Tabarin

GINO SEVERINI, 1912; oil on canvas with sequins; 63⅝ x 61 in. (161.6 x 154.9 cm).
Lillie P. Bliss Purchase Fund, The Museum of Modern Art, New York.
The rhythm of the dance is depicted in an abstract synthesis of fragmented figures and planes by this Italian Futurist painter. A man in a top hat and monocle, a woman in a purple skirt and red petticoat, the head of a cello, and the words "polka," "valse" (waltz), and "bowling" are all interwoven into this oil painting which sparkles with curlicues of applied sequins.

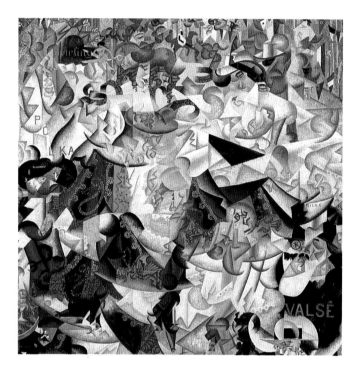

THE FUTURISTS

Although Paris was certainly a center of sophistication and the avant-garde, it was also prone to outside influences. One such influence was the Italian Futurist Exhibition held in 1912, which attracted international attention. Futurism was an Italian movement in painting, sculpture, and literature that began with Filippo Tommaso Marinetti's first manifesto in 1909 glorifying danger, war, speed, and the machine age. The manifesto also attacked academies, calling for the destruction of museums, libraries, and other bastions of the establishment. Marinetti declared that "the world's splendor has been enriched by a new beauty; the beauty of speed. A racing motor-car, its frame adorned with great pipes . . . is more beautiful than the Victory of Samothrace." (The Victory is the now headless marble sculpture of the female winged Greek Goddess Nike, c. 200 B.C., long upheld as an ideal of beauty, which resides in the Louvre in Paris.) The art of the Futurists was related to Cubism in its use of fragmented planes, as can be seen in the paintings of Gino Severini, Carlo Carrà, and Giacomo Balla. The sculptures of Umberto Boccioni, such as his bronze *Unique Forms of Continuity in Space*, shows his successful striving to give expression to the problem of dynamism, motion, and speed in the human figure. *The Futurist Technical Manifesto* of 1910 gave voice to the chaos of modern life even as it glorified it, declaring that the "motor-bus rushed into the houses which it passes, and in their turn the houses throw themselves upon the motor-bus and are blended with it."

Futurist painting devices such as the portrayal of movement through repeated images, speed lines, and geometric Cubist fragmentation became important to Art Deco artists seeking to portray the speed and dynamism of modern life in the machine age. Another Italian artist, living and working in Paris from 1906 to 1920, was to be influential on Art Deco's development, but for different reasons. Amedeo Modigliani, a talented painter and sculptor, portrayed the human, primarily the female form, with a mannered and elongated rendering of bodies and facial features that became an inspiration to the elegantly stylized repertoire of Art Deco. In Modigliani's *Reclining Nude*, for example, the woman's torso is at least one third longer than is anatomically possible—an exaggeration that gives the effect of great elegance. Art Deco artists were quick to pick up on the potential for chic that exaggeration of the human body afforded, and it became one of the hallmarks of the style.

Unique Forms of Continuity in Space

UMBERTO BOCCIONI, 1913; bronze; 43 in. high (109.2 cm).
Lillie P. Bliss Purchase Fund, The Museum of Modern Art, New York.
As a member of the Italian Futurist movement, Boccioni sought to express the speed of the human figure in motion by creating a symbolic, transcendent image that seems to float on winged feet. Speed, emblematic of the machine age, was a favorite Art Deco subject which the Futurists had pioneered.

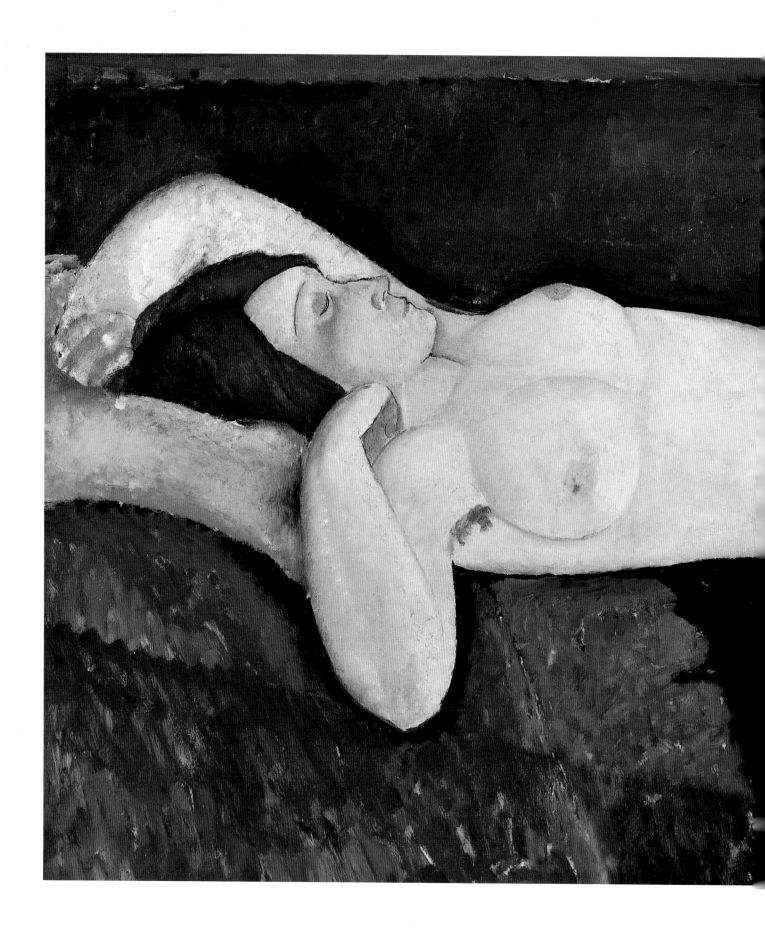

**Reclining Nude
(Le Grand Nu)**

AMEDEO MODIGLIANI, 1917;
oil on canvas; 73 x 116 cm.
(185.4 x 294.6 cm).
Mrs. Simon Guggenheim
Fund, The Museum of
Modern Art, New York.
Modigliani painted nudes
and portraits in a beautiful,
graceful style that reduced
the human face and figure
to elegant geometries. He
often exaggerated the length
of the faces, necks, and tor-
sos of his figures, a manner-
ism that became popular
with other Art Deco artists.

"Skyscraper" Cocktail Service with "Manhattan" Serving Tray

NORMAN BEL GEDDES; manufactured by the Revere Brass & Copper Co.; chromium-plated metal. Gift of Paul F. Walter, The Brooklyn Museum, New York.

Created by a noted American industrial designer, this cocktail service makes reference to the stepped-back silhouettes of Manhattan skyscrapers such as the Empire State Building. The clean lines and lack of ornament display the tendency toward "streamlining" that characterized the later Art Deco style.

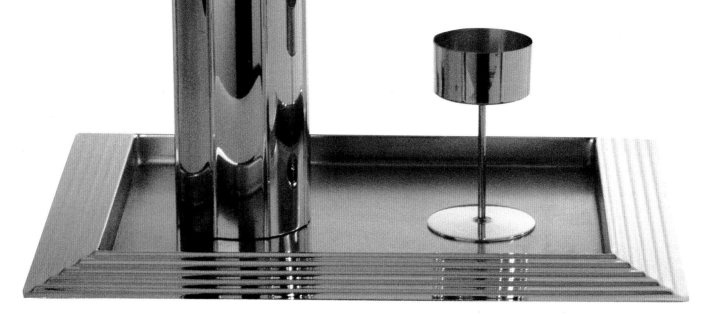

ACCESSORIES OF THE JAZZ AGE

The era of the twenties was renowned for its music—not only the music of the ballet but also jazz. Not coincidentally this period is often referred to as the Jazz Age. A music based on improvisation with swinging, syncopated rhythms, jazz was an American music form that originated within the African American community and from other folk influences. From its birthplace in New Orleans, it moved north to Chicago and New York; jazz styles included ragtime, blues, scat, swing, bop, and boogie-woogie. By the end of the First World War, jazz had found a wide audience in the United States and soon crossed the Atlantic to Europe. American singer and dancer Josephine Baker became a sensational success in Paris in 1925 in *La Revue Négre* ("The Black Revue") and began a craze for jazz in that city, as well as for African American culture in general. Baker continued to live and perform in Paris, becoming a naturalized French citizen in 1937.

The accessories of life in the twenties took on the "Moderne" look of Art Deco. Cigarette cases, such as the one created by French jeweler Raymond

Cigarette Case

RAYMOND TEMPLIER, 1930; silver, aluminum, and lacquer; 5 x 3³⁄₈ in. (12.7 x 8.5 cm). Musée des Arts Décoratifs, Paris.

In the Art Deco era, smoking by both sexes became associated with a glamorous lifestyle and the silver screen. The cigarette case became an object of luxury and illusion—a prop designed to accompany the fantasies of modern life.

Templier in a geometric dazzle of red, silver, and black, expressed the fervent mood of the times. Other paraphernalia of smoking and drinking, such as American designer Norman Bel Geddes' skyscraper cocktail service with Manhattan serving tray, were equally fashionable. Women were freed from the confines of Victorian morals and began to participate in these rituals of modern life on an equal basis with men. In 1920 the Nineteenth Amendment to the Constitution of the United States granted nation-wide suffrage to women and, in England, the efforts of a vocal suffrage movement led by Emmeline Pankhurst and her daughters finally brought full voting rights to women in 1928.

From 1919 to 1933, American prohibition laws outlawing the manufacture, transportation, and sale of alcoholic beverages only served to increase the demand for and fashionable cachet of liquor. Not only were smoking and drinking now common habits for women but, thanks to the fashion genius of Paul Poiret, women were also freed from the confines of bustles and corsets. The fashionable female silhouette became long, tubular, and unadorned and, by 1917, the low-waisted dress replaced the high-waisted dress and skirts started going up. The new look called for simple jewelry such as long necklaces. Bobbed hairstyles and cloche hats looked best with pendant earrings; sleeveless dresses made bangles popular and the brooch was a versatile addition to belts, hats, or shoulders. Geometric patterns for the new style were drawn as much from Cubism as they were from the ancient civilizations of the Egyptians, Babylonians, Africans, Persians, Chinese, Aztecs, and Mayans. In particular, interest in Egypt was sparked by the discovery in 1922 of King Tutankhamen's tomb.

Women dressing in men's clothes were no longer unheard of, and homosexuality became somewhat fashionable. American artist Romaine Brooks' paintings offer a glimpse into the lives of wealthy lesbians of the period. Women driving motor cars became yet another symbol of the era, portrayed in numerous posters and painted by artists such as Tamara de Lempicka. The equation of speed, cars, and sex developed into an advertising cliché that remains popular today. As modern life evolved, so did the style of Art Deco. The stylized flowers, women, deer, and fountains of the early lyrical period gave way to geometric patterns such as zigzags, chevrons, lightening bolts, speed lines, and sunbursts that expressed so well the astonishing energy of the times.

Self-Portrait

ROMAINE BROOKS, 1923;
oil on canvas; 45⅞ x 26⅝ in.
(117.5 x 68.3 cm). National
Museum of American Art,
Smithsonian Institution,
Washington, D.C.

By painting herself in male attire, Brooks displayed the sexual ambiguity of an era in which homosexuality was somewhat fashionable. Brooks moved in a circle of wealthy lesbians whose lives she depicted with a ruthless honesty.

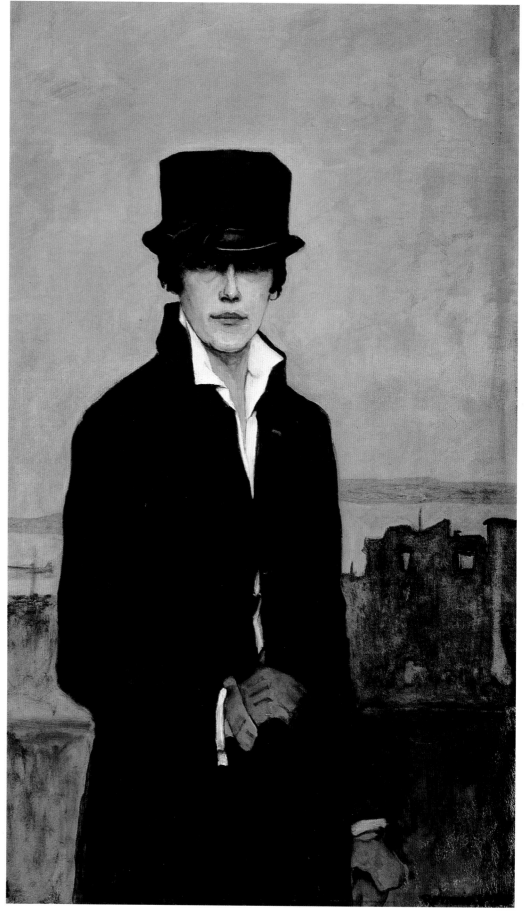

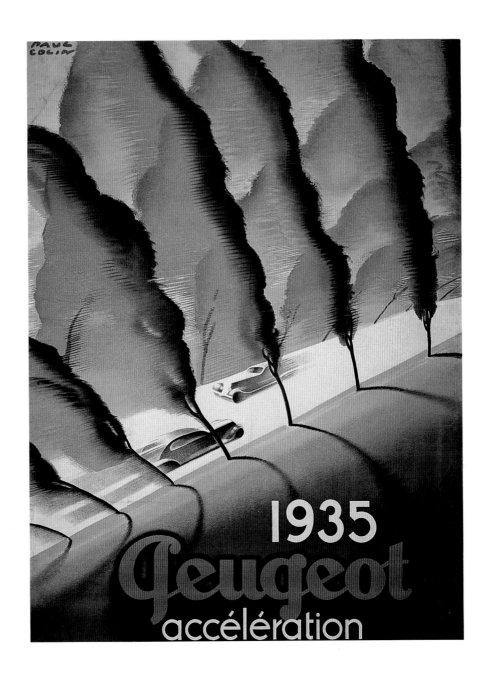

Peugeot (Accélération)

PAUL COLIN, 1935; lithograph; 63 x 46¾ in. (160 x 118.7 cm).

Gift of Bernard Davis, The Museum of Modern Art, New York.

The speed of the motor car was one of the icons of the Deco age.

The parallel "speed lines," as seen in both the cars and the passing trees

of this poster for a French auto maker, became increasingly stylized,

finding their way into all sorts of designs from building facades to wallpaper.

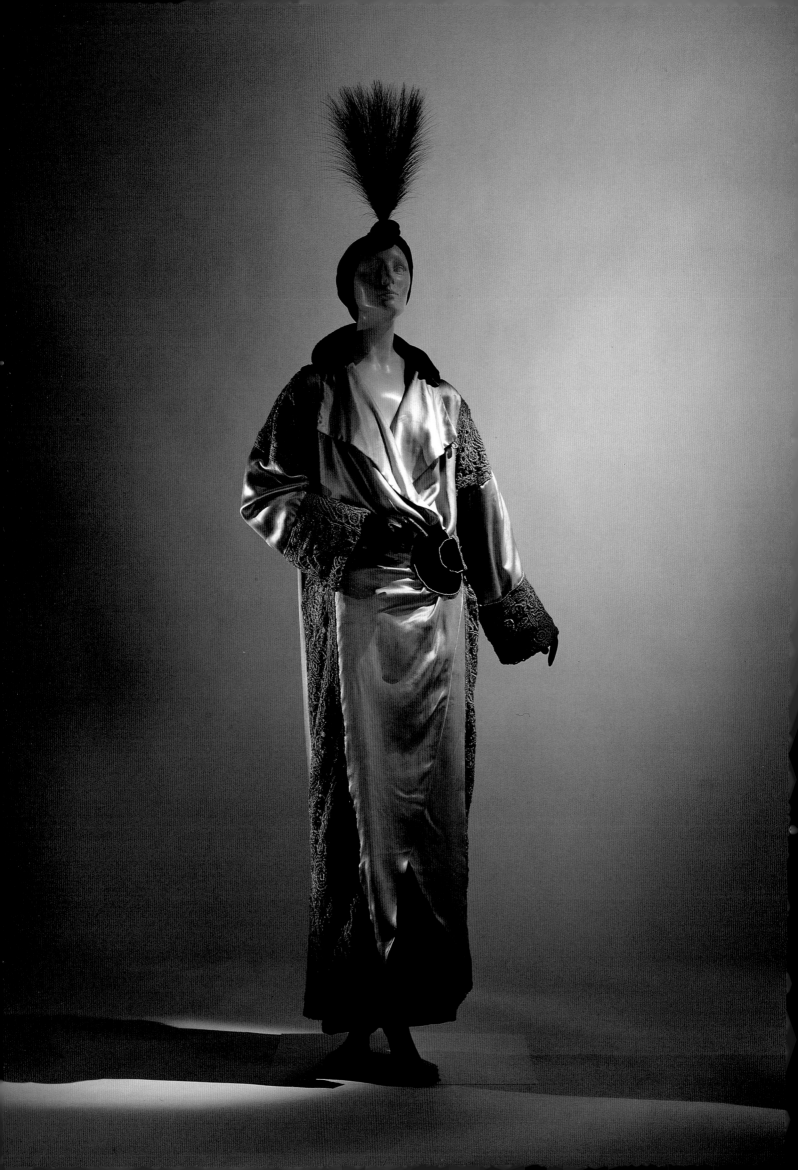

Flamenco

Erté; hand-pulled serigraph,
embossed and foil stamped; 41¾ x 26 in.
(106 x 66 cm). © 1997 Sevenarts
Ltd./use granted by Chalk & Vermilion
Fine Arts Ltd, Greenwich, CT.
Born in St. Petersburg, Russia,
as Romain de Tirtoff, Erté moved
to France and worked for dress-
maker Paul Poiret, sketching fashion
designs as well as designing opera
and theater costumes. His sophisti-
cated and highly stylized designs
remain popular to this day.

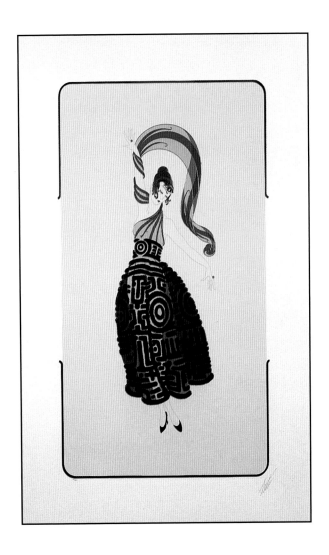

Theater Coat

Paul Poiret, 1912. Purchase, Irene
Lewisohn Trust Gift 1982 (1982.350.2),
The Metropolitan Museum of Art, New York.
The fashion designs of famed couturier
Poiret perfectly fit the Deco spirit.
Here, a theater coat of yellow and pale
blue silk charmeuse, trimmed with
black velvet and silver lace, gives a taste
of the stylized elegance of the period.

Wedding Gown and Train

PAUL POIRET, 1929.
Gift of Mrs. Van Heukelom
Winn, 1974 (1974.261abc),
The Metropolitan Museum
of Art, New York.
Poiret's wedding gown,
with its low, loose waist
and relaxed yet ever-so-
elegant drapery, shows how
radically women's styles
had changed since the
confinement of turn-of-the-
century corseted fashions.

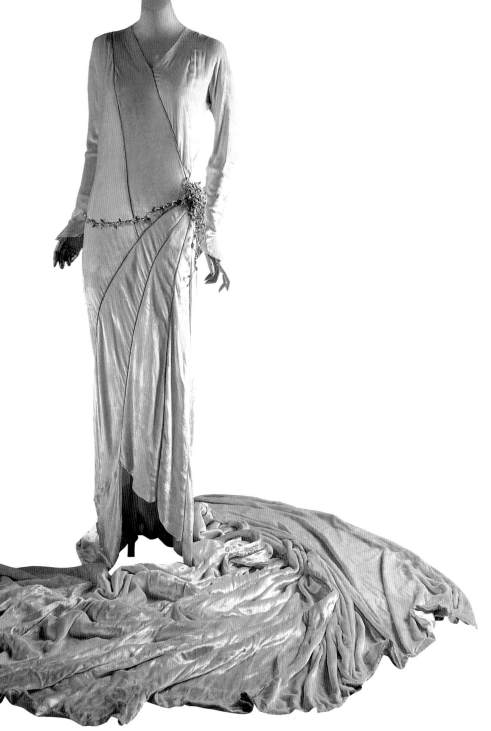

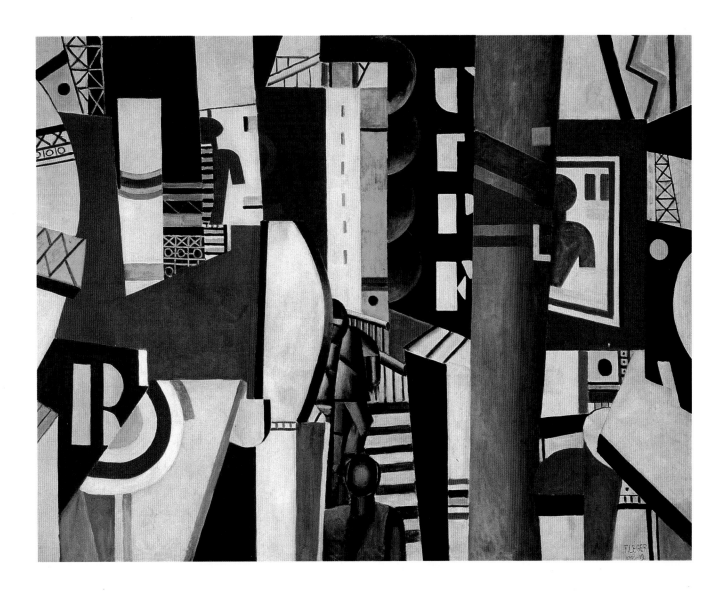

The City

Fernand Léger, 1919; oil on canvas; 91 x 117¾ in. (231.5 x 298.5 cm).

The A. E. Gallatin Collection, The Philadelphia Museum of Art.

Léger effectively communicates the restless spirit and tempo of the modern city in
this oil painting executed with the Synthetic Cubist technique of overlapping,
strongly colored planes. The people climbing stairs in the center of the picture have
here been reduced to the geometric simplicity of colorless machine components.

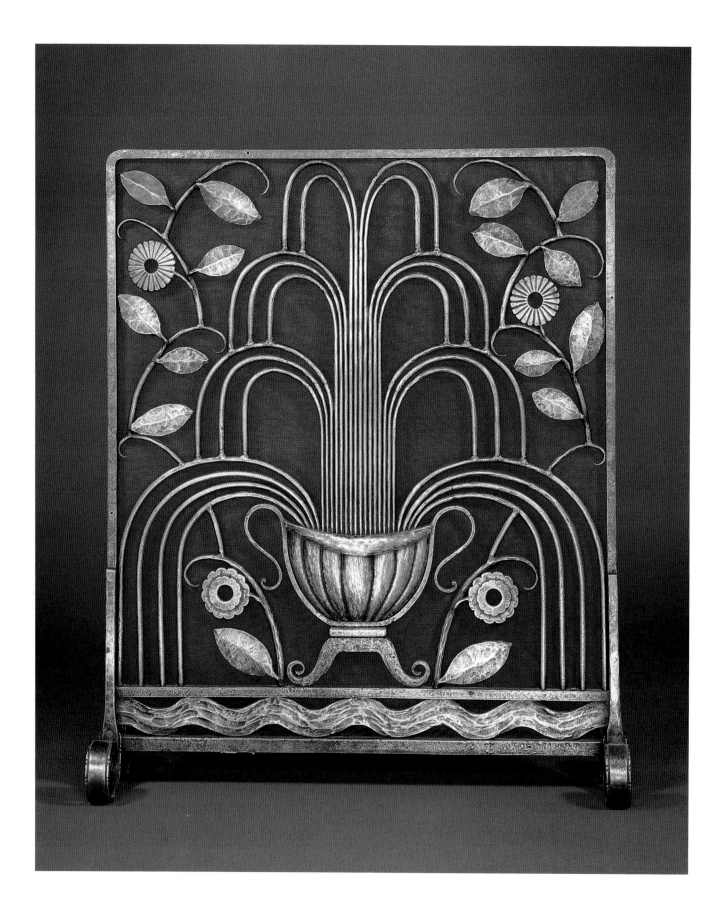

THE TRIUMPH OF THE DECORATIVE ARTS

Art Deco's triumph occurred from April to October, 1925, during the International Exposition of Decorative Arts in Paris at which most European countries were represented.

THE 1925 PARIS EXPOSITION

Originally planned for 1908, the Exposition had been postponed a number of times, in part because of the First World War. Over twenty nations participated; one exception was Germany, a significant omission from a design standpoint because of the innovations of the Bauhaus.

The United States did not participate because Secretary of Commerce Herbert Hoover felt that it could not meet the Modernist requirements for entry. The Exposition's charter limited the art styles represented to the present, expressly forbidding any blatant historicizing of the past, and Hoover did not feel that the United States had yet produced any work of sufficient originality. Nevertheless, the Exposition was a great stimulus for American design. The Hoover commission sent to Paris a 108-member delegation,

composed of trade organizations and art guilds, in order to encourage American industry to establish leadership in design innovations.

Occupying a huge area in the center of Paris, the Exposition held over 130 exhibits of artistic,

Pomone Pavilion of the Department Store, Au Bon Marché

L. H. BOILEAU, architect. International Exposition, Paris. 1925.
This temporary pavilion built for the Paris International Exposition of Decorative Arts is an example of classic early Art Deco. The stepped masses of the structure lead the eye to the monumental entryway above which a large tympanum of semi-abstract ornament displays decorative lettering. Note also the zigzag motifs.

Fireplace Screen with Fountain Design

EDGAR BRANDT, c. 1924; wrought iron. Gift of Cheney Brothers, 1924 (24.211), The Metropolitan Museum of Art, New York.
The stylized or "frozen" fountain motif was a staple of early Art Deco. In the hands of a master ironworker it takes on new life and energy as the water reaches skyward in a series of curving, stepped cascades interwoven with simple flowers, stems, and leaves.

commercial, and industrial establishments, and hundreds more of individual artists. It was a showcase for avant-garde French architecture—the influential and much publicized pavilions were built primarily in the style that came to be known as Art Deco.

The Exposition period produced a wealth of decorative objects, furniture, textiles, and sculpture. These objects were created with the Art Deco tenet—stating that form must follow function—in mind, but they also were formed with the idea that decoration entailed elaborate workmanship devoted to finely crafted, one-of-a-kind pieces, or perhaps as part of a limited edition. This lofty ideal fell by the wayside with the advent of Modernism and the modern school of thought, which held that excellent design should be accessible to anyone; mass production, modernists believed, did not necessarily have to mean a reduction in quality.

JEWELRY

Art Nouveau had already redefined jewelry by popularizing semiprecious stones, such as the opal, instead of relying heavily on the diamond as had jewelry of the Victorian era. And while Art Nouveau jewelry by masters such as René Lalique drew inspiration from nature, elaborately imitating forms seen in flora and fauna, Art Deco jewelry by masters such as Raymond Templier displayed a commitment to simplicity and a geometric style that related to movements in avant-garde painting of the period. Some of Templier's work employs strong contrasts created by the use of colored lacquers in conjunction with gold and diamonds.

Some other names in the primarily French movement of Art Deco jewelry design were Paul-Emile Brandt, Jean Desprès, Jean and Georges Fouquet, and the firms of Van Cleef & Arpels and Cartier. The trend in jewelry design progressed from the more delicate colorful creations of the early twenties into bolder designs with muted colors and stark contrasts of black and white, achieved, for example, by the use of onyx and diamonds. With the stock market crash of 1929 and the onset of the Depression, the demand for luxury items went flat. Jewelers tried to attract consumer interest with multi-use jewelry; for instance, a pendant that could also be worn as a brooch, or a necklace that came apart to form a pendant and two bracelets. The Depression era also created a market for inexpensive costume jewelry, made from base metal or silver and set with imitation stones, or from some of the new synthetic substances such as Bakelite, a plastic resin.

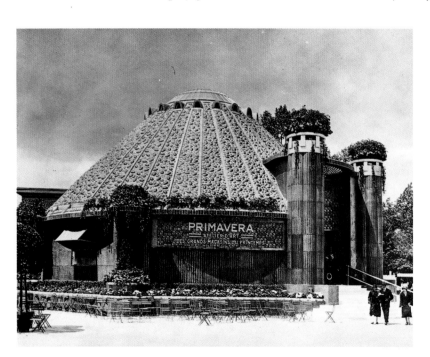

Primavera Pavilion

HENRI SAUVAGE & WYBO, architects. International Exposition, Paris. 1925.
Representing a major French department store, this unusual Art Deco exposition pavilion combines a circular Quonset hut or igloo design with massive columns, floral ornament, and green plantings to achieve a dramatic presence. The entrance canopy is flanked by thick columns crowned with giant planters which bring to mind a fantasy temple to some long forgotten deity.

Bracelet

JEAN FOUQUET, c. 1925; onyx, yellow and white gold.
Primavera Gallery, New York.
This bold yet graceful design is typical of the French Art Deco jewelry design movement. Here, strong geometric patterning exploits the contrast between materials, accented by the elegance of shining gold.

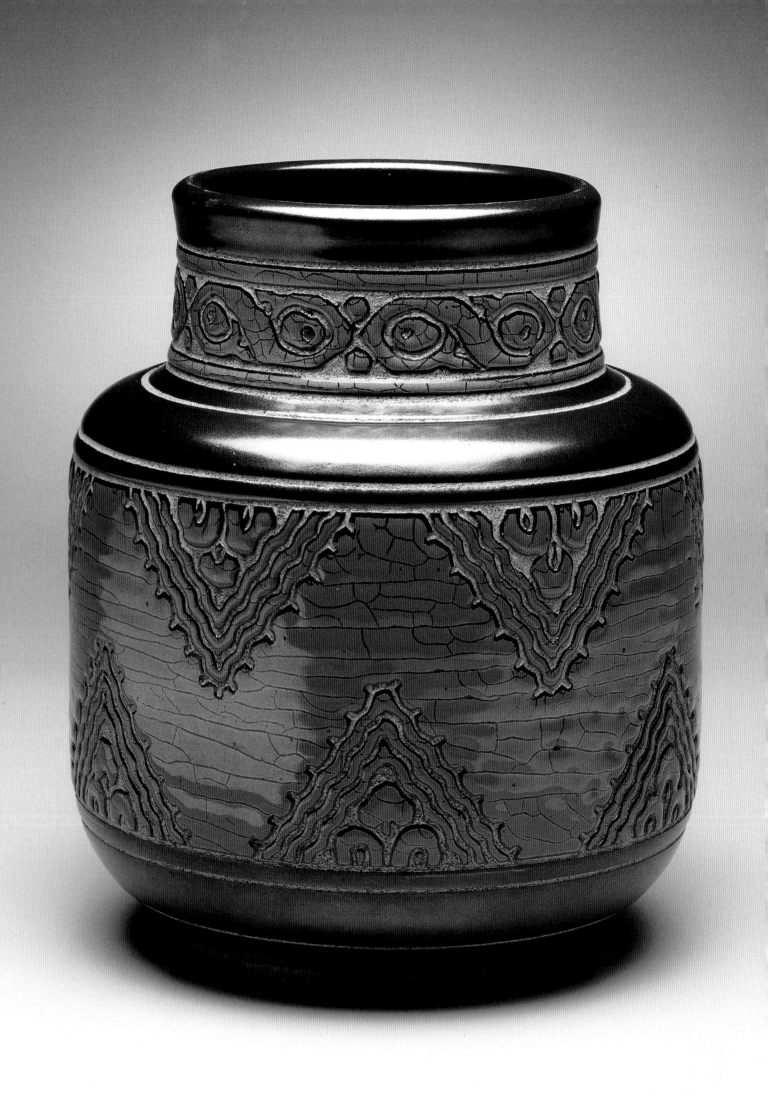

FAVORED MATERIALS

Another material Art Deco artists made inventive use of was lacquer, which had an ancient tradition in China, Japan, and India but was a relative novelty in Europe (although it had been used in France since the seventeenth century). Jean Dunand, an innovative furniture designer, became one of the leading Art Deco exponents of lacquer. He moved from floral embellishments to geometric decoration and from there to panels painted with all manner of subjects and styles, from African and Oriental motifs to abstractions. In a screen showing a stylized angel, Dunand applied the technique of inlaying crushed eggshell, which then became a popular addition to his work.

Metal was a material which lent itself even more readily to design in the machine age; indeed, Alastair Duncan called the years between the wars "a golden age for wrought iron in France." The new architecture used metal not only as a structural support but was em-

ployed for grilles, doors, elevators, railings, fireplace fixtures, lighting, and furniture as well. The graceful, stylized form of a spurting fountain among leaves and flowers illustrates the mastery Art Deco ironworker Edgar Brandt had of the material. Eliel Saarinen's andirons in the form of two peacocks show the sleek delicacy with which natural forms were assimilated into the Art Deco aesthetic. Metalworkers soon moved from iron and bronze to the newer materials such as steel, aluminum, and chromium. Shining metal ornament—its warmth or coolness, its hardness, its sheen—is integral to the Art Deco decorative style.

Ceramics and glass also enjoyed a period of revitalization and innovation during the Art Deco years. Geometric designs contributed to the new look in ceramics, as can be seen in an Emile Lenoble vase as well as in the lyrical figural decoration in a vase by René Buthaud. Ceramics, however, did not by their nature lend themselves to the harder geometries of Art Deco

Andirons

ELIEL SAARINEN, 1929; bronze. Cranbrook Art Museum, Bloomfield Hills, Michigan. These stylized peacock andirons have a simple elegance that is characteristic of Saarinen's work. Their bodies seem formed of a single gestural flourish, while their feet rest upon stepped pyramids which relate to Aztec or Mayan architecture.

Stoneware Vase

EMILE LENOBLE, 1925. Cranbrook Art Museum, Bloomfield Hills, Michigan. This Art Deco vase is decorated with a simple geometric design of concentric circles inside of diamonds incised into the clay. The neck of the vase is surrounded by a zigzag which contributes to the bold contrasting pattern.

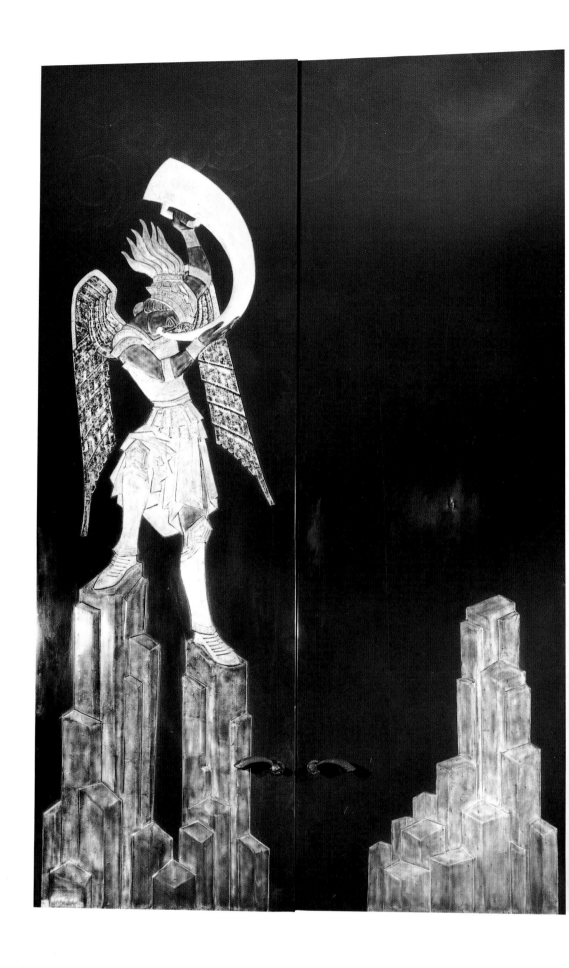

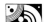

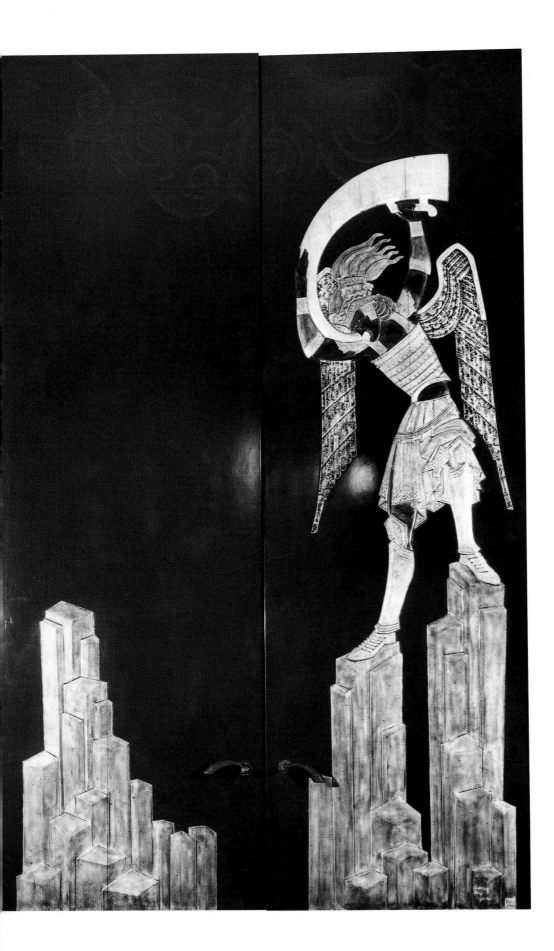

Lacquer Screen Doors with Design of an Angel and Rocks

SERAPHIN SOUDBININE, design; executed by JEAN DUNAND, 1925–26; inlaid with eggshell and mother-of-pearl. Cooper-Hewitt Museum of Design, Smithsonian Institution, New York.

Stylization and geometry are hallmarks of this design, rendered in lacquer by one of the Art Deco masters. The trumpet-blowing angel's hair extends outward in the stiff gravity-defying waves that were a popular motif of the era, while the rocks are so vertically crystalline they resemble a city skyline.

as well as other materials. Glass makers revealed new technical expertise in their work, as illustrated in a molded and acid-etched vase by René Lalique, with high relief scrolls outlined in black enamel. Lalique moved away from the Art Nouveau jewelry style and continued his innovative work with glass, which he had begun in his search for inexpensive jewelry materials. Another glass artist, Maurice Marinot, was acclaimed for his unique and experimental work, as was the firm of Daum, and many others in France. In the United States, the Steuben Glass Company produced editions of art glass with images derived from the 1925 Paris Exposition, and in the 1930s the Libbey Glass Company was at the forefront of commercial glass design. Glass was also used as an architectural material, and was favored in the development of modern furniture and lighting.

A PORTFOLIO OF FURNITURE

By the mid-1920s the French had become world leaders in the decorative arts. Their work was distinguished by a fine sense of proportion and craftsmanship as well as a sense of color, luxury, and frivolity that made it unusually appealing. In particular, the use of rare and expensive woods such as ebony, palmwood, Brazilian jacaranda, zebrawood and calamander, and the use of traditional veneers in combination with contrasting burl wood gave Art Deco furniture a distinctive look. Other popular materials included lacquer, shagreen (the skin of the spotted dogfish), sharkskin, ponyskin, ivory, and wrought iron.

A pair of chairs made by Clément Rousseau combines rosewood, sharkskin, ivory, and mother-of-pearl in a superb interplay that is both personal and whimsical. Rousseau has transformed ordinary chairs into museum-quality luxury objects, veneered with stained sharkskin and accented by thin bands of ivory. Other fine Art Deco French cabinetmakers include Adolphe Chanaux and Clément Mère.

Another school of fine furniture makers was centered in Austria's Wiener Werkstätte ("Vienna Workshops"). Joseph Urban, who emigrated to the United States in 1911 from his native city of Vienna,

designed a table of black lacquered and silvered wood, silk, and glass. The strongly rectilinear forms and bold light and dark contrasts are typical of the Viennese style, as is the sense of luxury and fine decoration.

Eugène Schoen was a native New Yorker who also had ties to the Viennese tradition. He had run his own architectural practice since 1905, but after he visited the 1925 Paris Exposition he was inspired to set up a successful interior design business. Schoen made full use of the potential of exotic woods and veneers in his large buffet, employing walnut, bubinga, imbua burl, Macassar ebony, and rosewood. When the piece entered the collection of the Philadelphia Museum of Art in 1929, the curator declared it "the finest piece of furniture made by an American craftsman in the modern manner."

Irish born and London educated at the Slade School of Art, Eileen Gray settled into Paris in 1902 for a long and inspired design career. A brilliant individualist, Gray opened her own workshops and boutique, where her own furniture and rugs were sold. Almost from the start, her furniture designs anticipated the International style, although she also incorporated influences from France and the Far East. Although she rejected the past and denied kinship with the Art Deco movement, Gray's work nonetheless stands squarely within it. The material of most interest to Gray for many years was lacquer, although after 1925 she introduced chromed tubular steel and aluminum into her furniture; its look, as a result, became increasingly modern. Her strikingly theatrical and luxurious canoe-shaped chaise longue ("long chair") was inspired by African art.

Pair of Chairs

CLÉMENT ROUSSEAU, c. 1925; rosewood, sharkskin, ivory, and mother-of-pearl. Gift of Sydney and Frances Lewis, Virginia Museum of Fine Arts, Richmond, Virginia.
The backs of these finely made chairs are decorated with stylized inlaid floral motifs. The legs are veneered with stained sharkskin, while thin bands of ivory accent the lines of the legs and seat and contrast with the warm color of the rosewood.

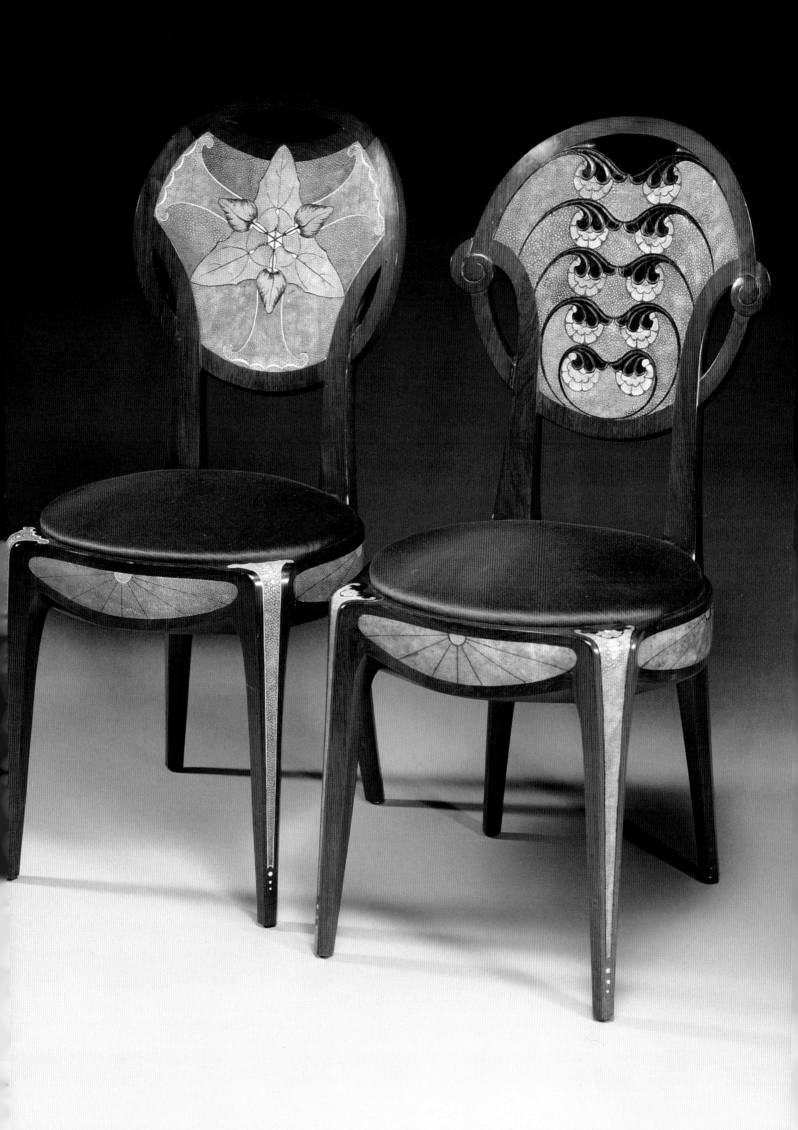

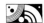

FROM CRANBROOK TO COMMERCIALISM

Founded in 1932 by George Booth in a Detroit, Michigan, suburb as an art school, atelier, and art colony, Cranbrook became an important influence on design in America after the Second World War. Booth was the chief American patron of the Finnish-American architect and city planner Eliel Saarinen, who was a resident of the United States after 1923. Saarinen designed several buildings at Cranbrook and headed the Academy of Art at the Cranbrook Foundation in Bloomfield Hills. The Cranbrook dining room was inspired by French Art Deco furniture, which Saarinen saw at the Paris 1925 Exposition. The chairs have classically fluted backs accented by the strong contrast of black-painted stripes against a pale fir veneer. The dining table featured complex geometric inlays in concentric circles, a pattern that was echoed in the design of the rug and the recessed circles in the ceiling. Saarinen believed in united design, hence every aspect of the dining room shared the same simplified shapes, enriched by careful attention to color and texture.

Both an architect and a furniture designer, New York-based Paul T. Frankl had been born in Vienna. His designs, such as a desk or his "skyscraper" bookcases, were inspired by the set-backs of New York buildings (required by the zoning code), the boxy style of Frank Lloyd Wright, and by International style architects and designers such as Walter Gropius and Le Corbusier, as well as the geometric preferences of the Vienna Secession. Frankl's use of ebonized wood and zebrawood, however, relates to the lavish materials utilized in the French Art Deco tradition.

After the Paris 1925 Exposition, American department stores such as Macy's and Lord and Taylor conceived of the idea of promoting a demand for modern furnishings by holding public exhibitions. These

Writing Desk

PAUL T. FRANKL, c. 1930; ebonized wood and zebrawood. The George Walter Vincent Smith Art Museum, Springfield, Massachusetts. A stepped silhouette, such as that suggested by New York skyscrapers, distinguished many of Frankl's furniture designs. The simple, open, boxy shapes of this desk are related to modern currents in architecture, while the use of expensive woods references the tradition of fine French cabinetmaking.

Side Chairs

ELIEL SAARINEN, 1929–30; wood, with black and ocher paint, red horsehair upholstery. Cranbrook Art Museum, Bloomfield Hills, Michigan. Contrast gives elegance to the fluted backs of these dining room chairs, designed to coordinate with a circular table and specially woven rugs and tapestries. The blond wood is accented by black-painted stripes, a color combination that became popular in many pieces of Art Deco furniture mass-produced in the 1930s and 1940s.

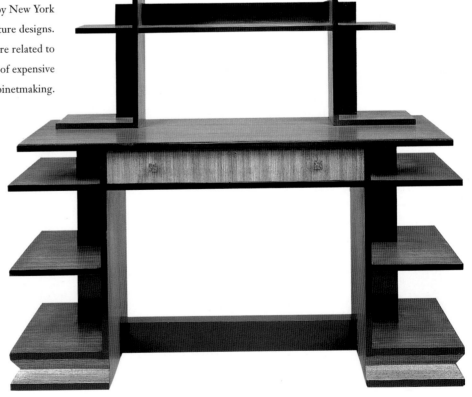

shows proved very successful in helping to popularize the new designs, and the "Moderne" look of Art Deco caught on well in the United States in the 1930s and 1940s. Streamlined pieces that looked as though they had been made by machinery, or even appeared as if they actually were machinery, enjoyed great popularity. The streamlined style had also been made fashionable by its use in the sets of Hollywood films. People wanted to buy furniture that looked like it could grace the houses of glamorous Hollywood movie stars such as Rita Hayworth.

Although there was a limited amount of finely made work, the great mass of Art Deco pieces were manufactured quickly and cheaply to satisfy popular demand. The Deco look favored blond mahogany veneer in simple boxy shapes with straight cuts, beige lacquer, or the curves of molded plywood. Pulls were simply designed in brass or chrome, or replaced altogether by finger holes. Black and blond lacquer combinations were also popular. Apartment living in the new skyscrapers meant space-saving, multi-purpose furniture; "the more compact the better" was much in demand. Manufactured for Lord and Taylor, a vanity and bench in red lacquered wood with chromium-plated hardware features unusual oblique planes which would probably only have appealed to a very adventurous buyer in 1931. It closely copies the design of a vanity created by Parisian cabinetmaker Léon Jallot that was exhibited at the 1928 Paris Autumn Salon.

In a way, the manufactured elegance of Marcel Breuer's armchair—made of chromium-plated tubular steel, painted wood, and canvas—signaled a final break with tradition that ended the Art Deco era and welcomed in the International style. As Breuer himself said: "Our work is unrelenting and unretrospective; it despises tradition and established

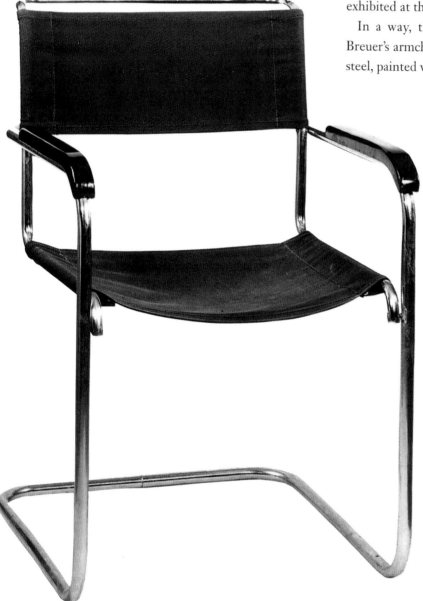

Armchair

MARCEL BREUER, designed 1928, manufactured 1933, retailed by Thonet Brothers, New York City; chromium-plated tubular steel, painted wood, and canvas. Purchased about 1934 for use in the Avery Building of the Wadsworth Athenaeum (1981.106), Wadsworth Athenaeum, Hartford, Connecticut. Breuer pioneered the use of tubular steel in furniture design and manufacture, inspired by the handlebars of his bicycle. This cantilevered chair design, which made back legs unnecessary, was revolutionary for its time, but has since been reproduced and copied so often that it seems ordinary today.

Rug with Animal Motif

MAJA ANDERSSON WIRDE, designer, and studio of Loja Saarinen, weavers, 1932; linen warp, wool weft, wool pile; plain weave with four picks of weft between each row of knots; 152 x 108 in. (386 x 274.3 cm). Cranbrook Art Museum, Bloomfield Hills, Michigan. Produced in the Cranbrook studio of master weaver Loja Saarinen, the abstract design and subtle colors of this carpet are purely Art Deco. The repeated forms of the animals suggest movement while the jagged pyramid forms surrounding them allude to the exotic architecture of the Mayan and Aztec civilizations.

custom." Yet this chair, designed by Breuer in 1928 and manufactured in 1933, also has a place in the history of Art Deco. Its shining, streamlined curves are not at odds with the Art Deco sensibility. Breuer had created the first tubular steel chair at the Bauhaus in 1925, after being inspired by the handlebars of a bicycle he had recently purchased. By 1929, several firms were manufacturing the new tubular steel product, although they were initially quite expensive. The strength of the steel allowed the chair to be constructed from continuously curved segments and, in a revolutionary step based on the principle of cantilevered construction, eliminated the need for back legs—thus giving the chair an entirely new, supremely modern shape. Ironically, this shape, which in its day was such a remarkable design development, was so popular that it has been manufactured and copied endlessly over the years. Its form looks completely ordinary—perhaps even uninteresting—to the contemporary eye.

RUGS, FABRICS, AND WALLPAPER

Rugs, fabrics, and wallpaper gained importance after 1925, adding color and texture to interiors that were becoming increasingly austere. Tastes in colors

changed rapidly from the bright shades inspired by the Russian Ballet to more muted tones suggested, in part, by the monochromatic nature of Cubism. Instead of printing designs on fabric, there was a growing interest in the nature of the woven material. The inherent beauty and texture of the fibers were emphasized by Bauhaus weavers such as Anni Albers and Gunta Stadler-Stölzl, whose careers flourished after the Second World War.

The studio of master Finnish weaver and designer Loja Saarinen, established at the Cranbrook Academy in 1928, was instrumental in spreading Scandinavian design ideas to United States. Her weaving was recognizable by its restrained palette of colors and the absence of both sharp geometry and purely representational subject matter. In a rug with an animal motif, designed by Swedish weaver Maja Wirde and produced at the studio of Loja Saarinen, stylized fauna, perhaps horses, are part of a geometric pattern that owes much to Pre-Columbian textile design. The muted blues, greens, and light earth tones are typical of work produced in Saarinen's studio.

In England, Omega Workshops was established in 1913 by Roger Fry along with his associates, the painters Vanessa Bell and Duncan Grant, to produce

objects of domestic utility such as pottery, furniture, fabrics, and rugs, all designed by top artists. The name Omega stands for the anonymity of collective work, and evokes the guild tradition upheld by William Morris and his followers. The actual products of the Omega workshop, however, were less about fine handicrafts and more about applying paint as decoration. The reach of both Matisse and the Cubists can be felt in the style of a lovely screen of *Bathers in a Landscape* by Bell, in which the forms of both the women and the landscape elements are simplified into their geometric components and defined by dark outlines.

In a more traditional mode, all the motifs of early French Art Deco are brought together in a garden scene wallpaper by an anonymous designer. Stylized baskets of flowers, such as the ones seen decorating Ruhlmann's corner cabinet, are interspersed among geometrically hung garlands. The symmetrical water of a fountain falls in balanced patterns, similar to Edgar Brandt's fireplace screen with fountain design. Strong light and dark contrasts are evident, as is the orderly way in which the elements of the design are arranged.

After studying at the Pratt Institute in Brooklyn, Lydia Bush-Brown, another American textile artist, spent a year in Syria where she drew inspiration from the art of Islam. Her *Syrian Olive Tree* hanging is executed in the technique of wax resist dying on silk, with a red and gray border representing the niche that forms the central design on Islamic prayer rugs. Bush-Brown's choice of motif, a lyrical genre scene of goats and their goatherd under the olive trees, owes much to

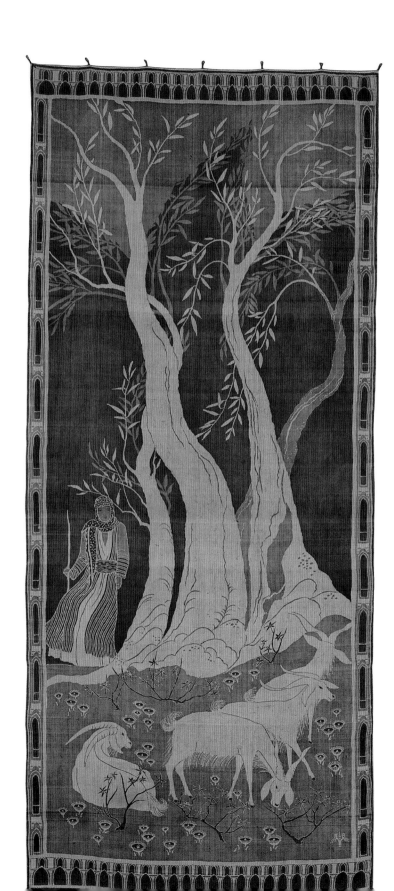

"Syrian Olive Tree" Wall Hanging

Lydia Bush-Brown, 1919–26; wax resist-dyed Chinese silk; cotton backing; 81¼ x 35 in. (206.5 x 90 cm). Gift of Lydia Bush-Brown (1974.23.2), Cooper-Hewitt, National Design Museum, New York.
Although the border has a jazzy modern quality, the style of this wall hanging was clearly inspired by motifs in Islamic art. Goats graze peacefully in a field of flowers under the watchful eye of a goatherd in traditional dress who stands by a grove of sinuous olive trees.

Bathers in a Landscape

VANESSA BELL, 1913; painted screen for the Omega Workshops; gouache on paper;

70¼ x 82 in. (178.4 x 208.2 cm). Victoria & Albert Museum, London.

In this lyrical scene of women bathing, Bell borrows from the simple decorative reductions of Matisse,

as well as from Cubism's fragmented planes. Created for the Omega Workshops, a London design

group, this screen takes the spirit of French avant-garde painting and transforms it to decorative furniture.

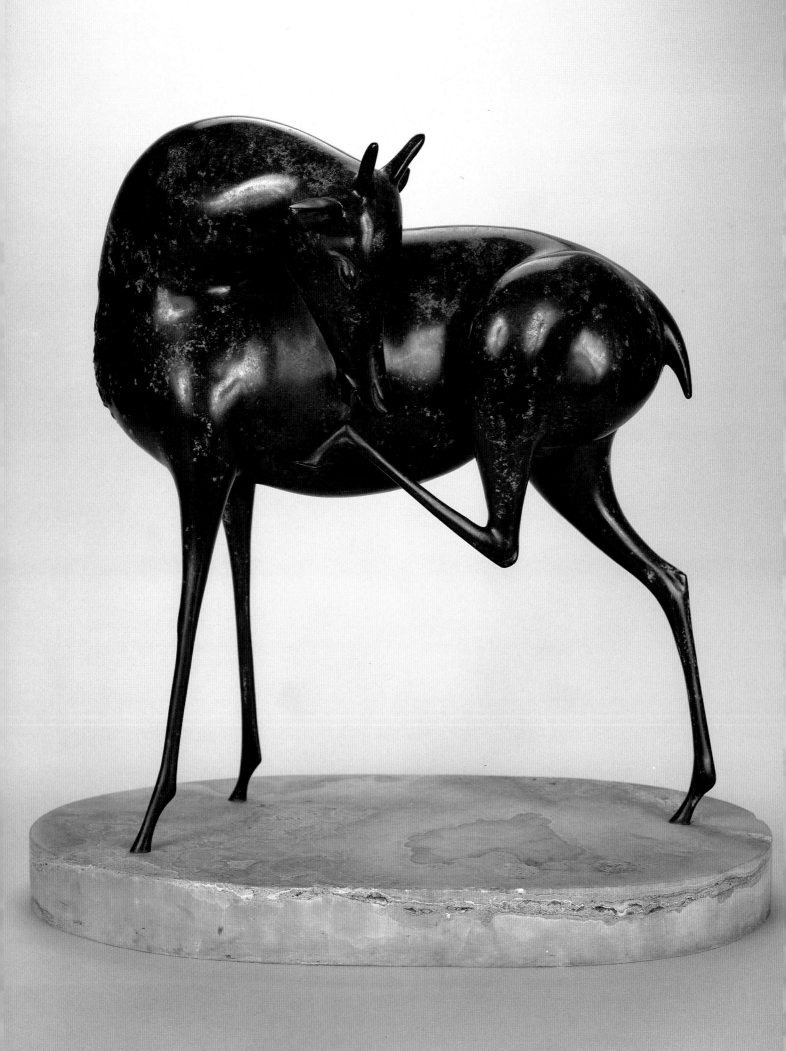

Persian miniature painting.

ART DECO SCULPTURE

Art Deco sculpture falls broadly into two categories: decorative work that was mass-produced for the domestic market and "fine art" pieces created by avant-garde artists and sculptors of the period. In general, Europe was more receptive to innovative sculpture than the United States, which was particularly conservative in this arena. But this changed with the influx of

talented emigrants between the wars, and also as a new generation of American artists set off to Europe to complete their art education, returning home to try out their newly acquired ideas. Quality sculpture and inexpensive work with mass appeal existed side by side—from marble and bronze to cheap plastic and ceramic souvenirs. In sculpture, the Art Deco style was responsible for a wide range of work, from fine art to kitsch.

Animal sculpture, always a popular genre that al-

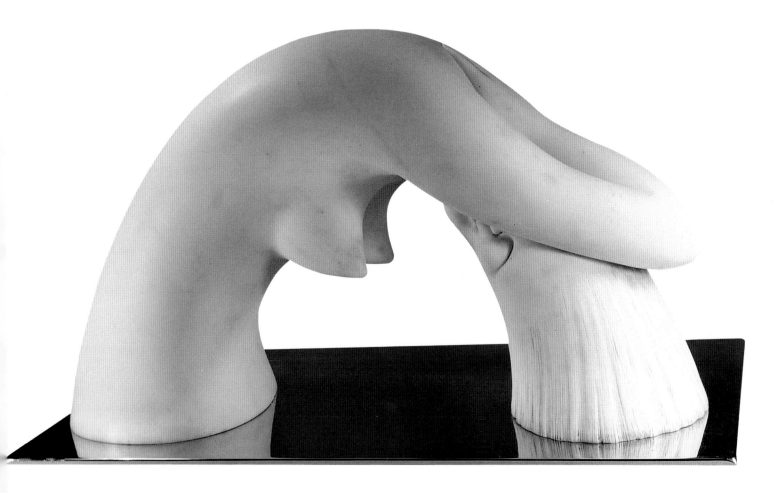

Standing Fawn

ELIE NADELMAN, c. 1914; bronze; 19 x 16 x 9 in. (48.2 x 40.6 x 22.8 cm). Bequest of Miss Ellen D. Sharpe, Museum of Art, Rhode Island School of Design, Providence, Rhode Island.

Smooth and simple forms define this forest creature standing gracefully with one leg bent upward. The fawn is an abstraction in Nadelman's hands; the texture of its coat is left to the imagination as the viewer's eye follows its streamlined surfaces.

Girl Washing Her Hair

HUGO ROBUS, 1940, marble, after original plaster of 1933. Abby Aldrich Rockefeller Fund, 1939, The Museum of Modern Art, New York.

The gesture of bending reduces the shape of this girl's head and torso to a simple arch that charmingly suggests her act of bathing. The exaggeration of the female form for the sake of elegance is typical of the Art Deco style.

lowed considerable leeway of expression, saw a change in the Art Deco era as artists began to simplify and streamline animal shapes. Instead of realistically portraying the textures of fur and feathers, the animal was reduced to its stylized essence. The *Standing Fawn* by Elie Nadelman is a poised creature of smooth and simplified volumes. The sculptor, who brought European ideas about art with him when he came to reside in the United States in 1914, had been born in Russian Poland and educated in Paris. Gaston Lachaise was another Paris-educated sculptor, who moved to the United States in 1906. Lachaise created the appealing *Dolphin Fountain* in 1924; the sleek bronze forms of the dolphins are playfully portrayed, with a special sensitivity to the nuance of their movements.

American-born sculptor Hugo Robus also captures the essence of a gesture in a sensual nude, *Girl Washing Her Hair*. Robus achieved an natural blend of the abstract and the anecdotal in his sculpture; the bent marble head and torso of the girl are streamlined into a simple arch, which is punctuated by the double cone-like forms of her breasts and her bent elbows. Another American ceramic sculptor, Waylande Gregory, captured the lighthearted and simple elegance of the Art Deco female in his white-glazed pottery figurine of *Persephone*, goddess of fertility and queen of the Underworld in Greek and Roman mythology. The Kansas-born Gregory was, for a time, a resident artist at Cranbrook, and he later became known for his monumental ceramic sculptures such as the *Light Dispelling Darkness* fountain in Edison, New Jersey, and *Fountain of the Atoms*, executed for the 1939 World's Fair in New York.

Art Deco commercial sculptures intended to adorn mantelpieces or tabletops were generally multiple-edition works, often of the bronze and ivory combination

Persephone

WAYLANDE GREGORY, c. 1930; white glazed figurine for Cowan Pottery; 15 in. high (38 cm). Cowan Pottery Museum, Rocky River, Ohio. Decorative statuettes, particularly of female subjects, were popular in the Art Deco era. The mythological subject serves primarily as an excuse to render a nude form that is both classically beautiful and fashionably mannered.

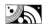

that came to be known as "chryselephantine." Ivory, today a banned substance, was in the late 1800s promoted by Belgium as an export from its African colony, the Congo. Bronze and ivory statuettes by masters such as Demêtre Chiparus and Alexandre Kéléty celebrated the fashions, arts, and celebrities of the day, from Nijinsky of the Russian Ballet to cabaret dancers.

Preiss-Kassler of Berlin, the firm of Ferdinand Preiss, also produced many Art Deco statuettes of dancers, athletes, and well-known personalities. Skaters were modeled after contemporary Olympic stars, while tennis, that fashionable pastime, was also a popular subject. Ivory was utilized for the faces, hands, and sometimes torsos of the figures to represent flesh while bronze was used to mold the figures and costumes, and was often cold-painted or gilded to add a sense of detail, realism, and luxury. The bases for the statuettes were frequently made of marble or onyx,

Dolphin Fountain

GASTON LACHAISE, 1924; bronze; 17 x 39 x 25¼ in. (43.1 x 99 x 64.1 cm).

Gift of Gertrude Vanderbilt Whitney, Whitney Museum of Art, New York.

Dolphins leap and play in this appealing bronze sculpture—their forms are fluid and lively, suggesting the movement of the waves in which they cavort. Lachaise has given great attention to recording the nuances of motion expressed by these lovely, sleek creatures.

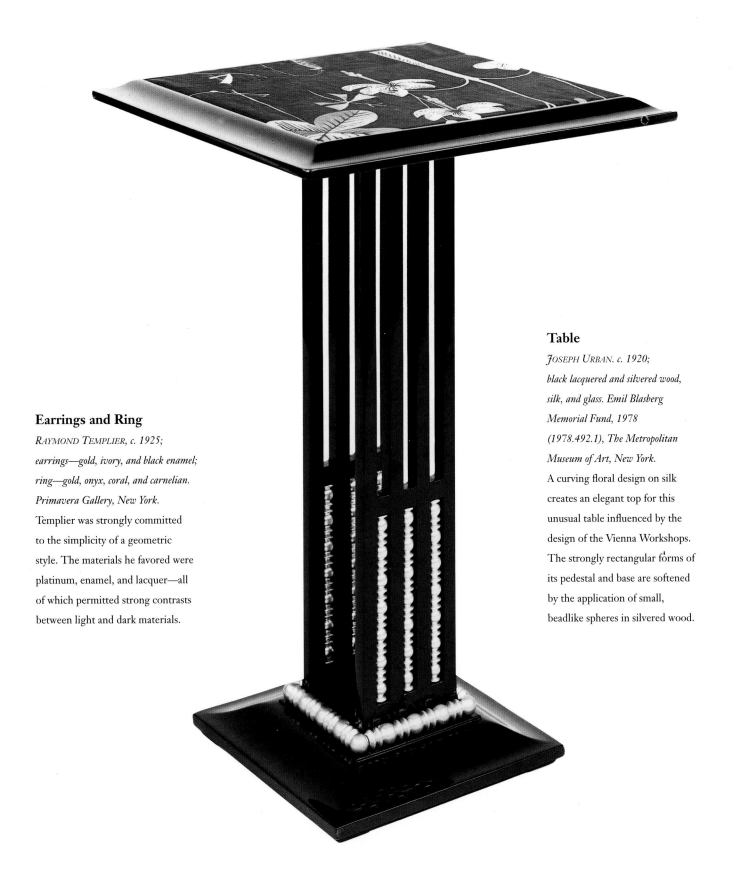

Earrings and Ring

RAYMOND TEMPLIER, c. 1925;
earrings—gold, ivory, and black enamel;
ring—gold, onyx, coral, and carnelian.
Primavera Gallery, New York.
Templier was strongly committed
to the simplicity of a geometric
style. The materials he favored were
platinum, enamel, and lacquer—all
of which permitted strong contrasts
between light and dark materials.

Table

JOSEPH URBAN. c. 1920;
black lacquered and silvered wood,
silk, and glass. Emil Blasberg
Memorial Fund, 1978
(1978.492.1), The Metropolitan
Museum of Art, New York.
A curving floral design on silk
creates an elegant top for this
unusual table influenced by the
design of the Vienna Workshops.
The strongly rectangular forms of
its pedestal and base are softened
by the application of small,
beadlike spheres in silvered wood.

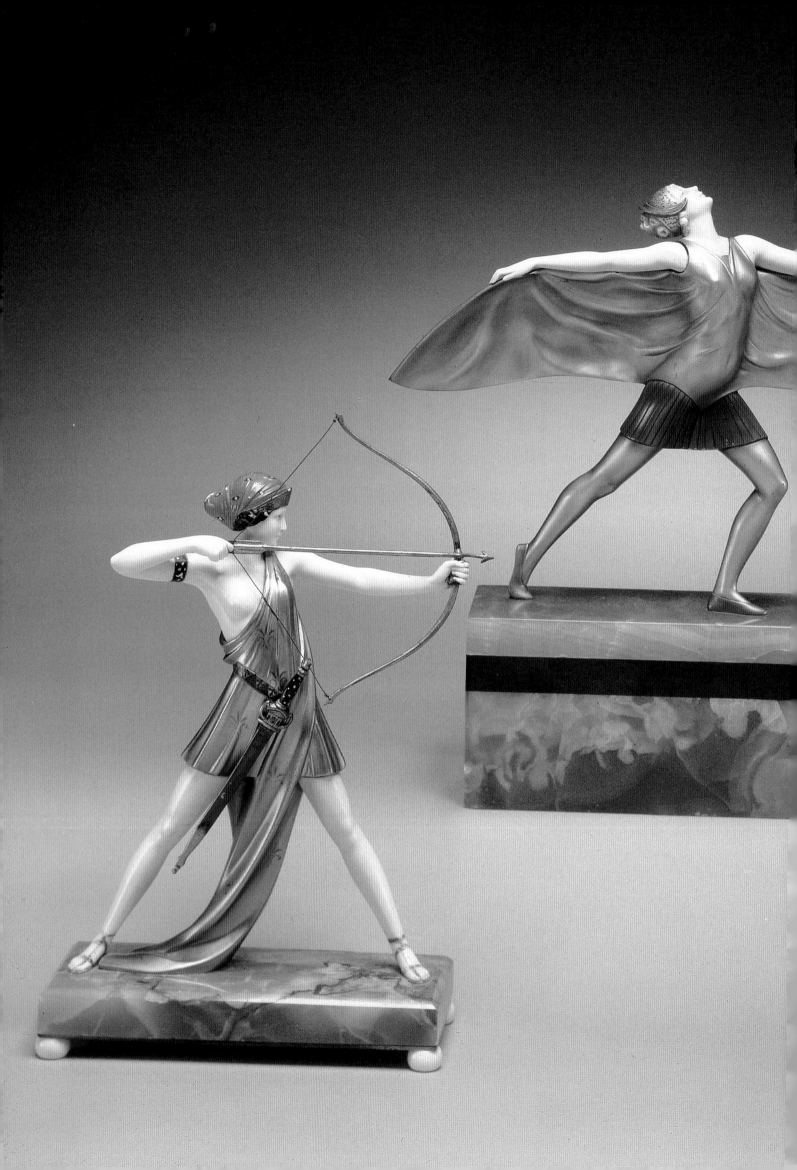

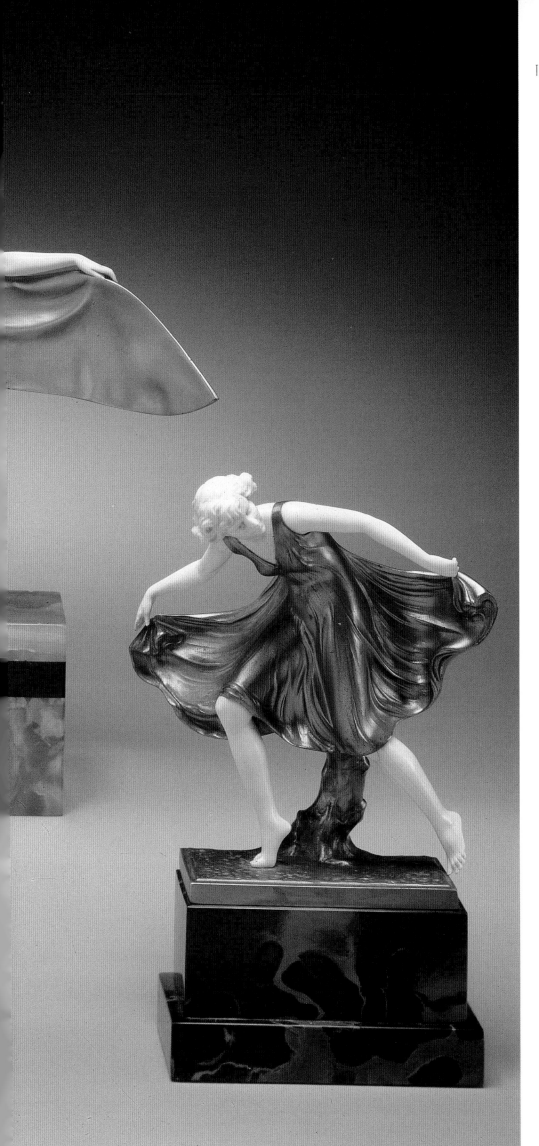

Archer, Bat Dancer, and Dancing Girl

JOHANN PHILLIPP FERDINAND PREISS, c. 1925; polychromed, gilded, and cold-painted bronze and ivory on marble bases. Sotheby's, New York. Dancing girls, women of fashion, celebrities, and athletes were all popular subjects for these commercially produced bronze and ivory statuettes. Details were added with paint or gilding for a realistic and elegant decorative effect.

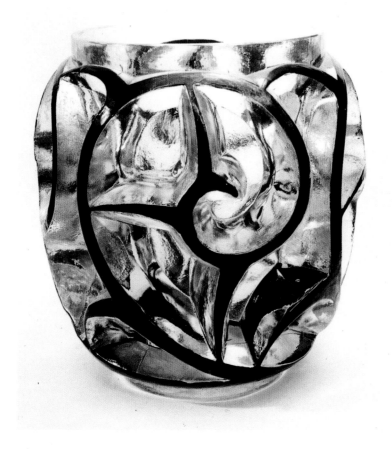

Tourbillons Vase

René Lalique, c. 1925; molded acid-etched glass carved with high relief scrolls outlined in black enamel. Cooper-Hewitt Museum of Design, Smithsonian Institution, New York. Lalique designed all manner of glass items from jewelry and perfume bottles to fountains and car mascots. The high relief effects he achieved by either molding, casting, or stamping glass are here enhanced by an application of colored enamel.

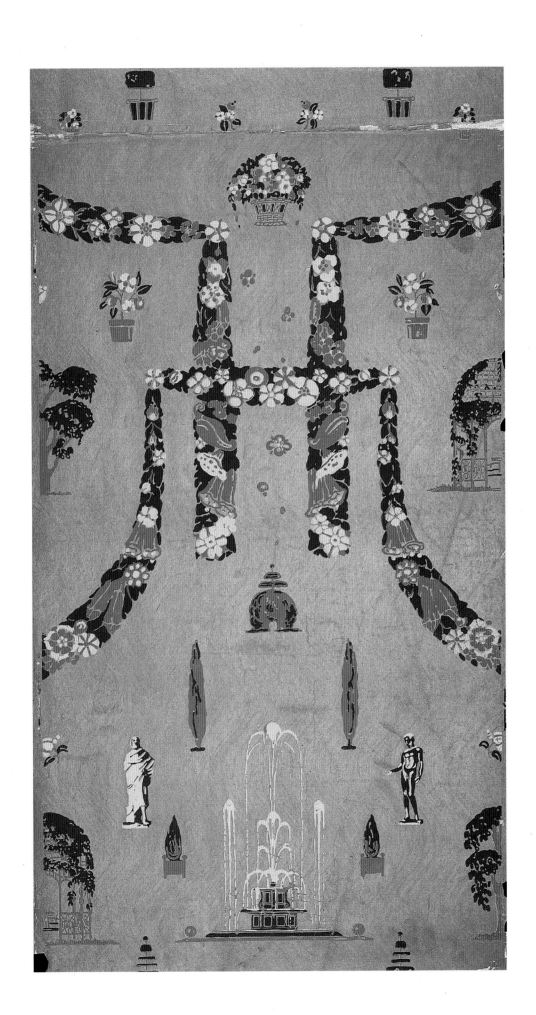

Garden Scene Wallpaper

Unknown French designer, 1920. Cooper-Hewitt, National Design Museum, New York.

The charming, stylized motifs of early French Art Deco appear in this delightful wallpaper, where baskets of flowers, simplified garlands, a fountain, a trellis, and several pieces of classical statuary punctuate the design in an orderly arrangement.

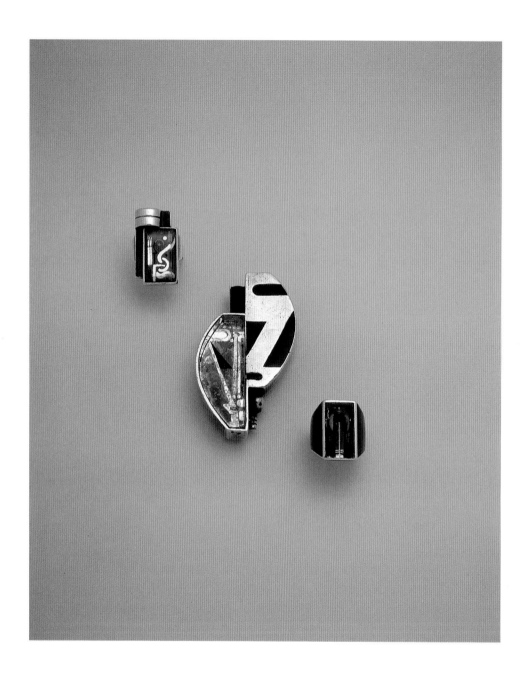

Brooch and Two Rings

JEAN DESPRÈS, c. 1925; silver and enamels, with painted mirror (verre eglomise)
elements by Etienne Cournault. Primavera Gallery, New York.

Jean Desprès, a goldsmith, silversmith, and jeweler, regularly exhibited his creations in gold and silver (including cigarette cases and table ornaments) as well as his jewelry. His work is starkly simple, with a brutal modernism, and the geometry of the design is clearly inspired by Cubism.

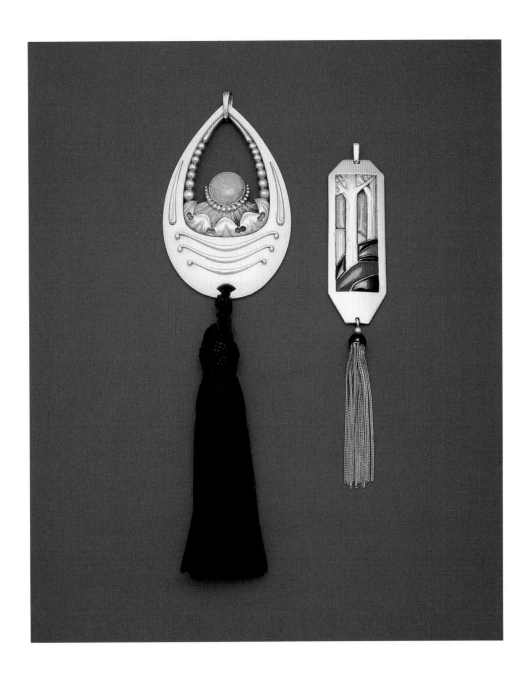

Pendants

JACQUES-EMILE DAVID, c. 1925; gold, with coral, onyx, and jade inlays.

Primavera Gallery, New York.

Colorful, stylized designs enliven these gold pendants created by a
prominent French Art Deco jewelry maker. The strong contrasts and bold geometric
simplicity are already many steps away from the natural scenes which inspired the designs.

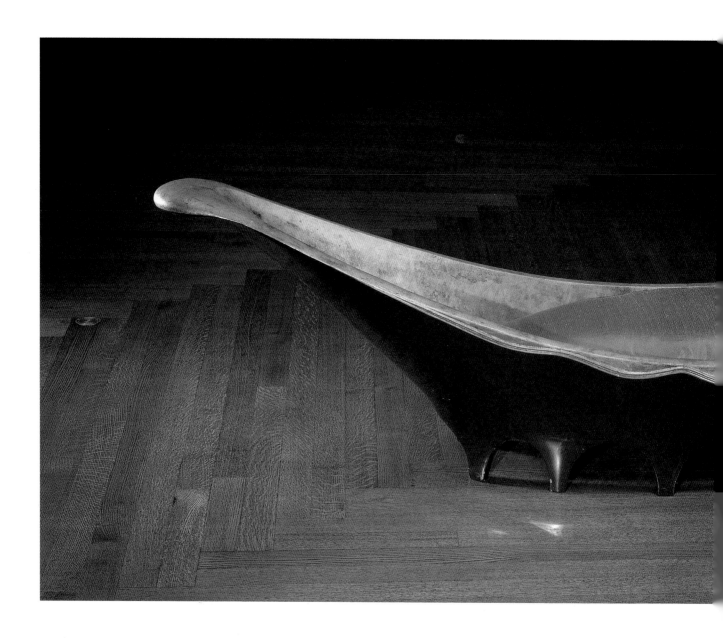

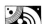

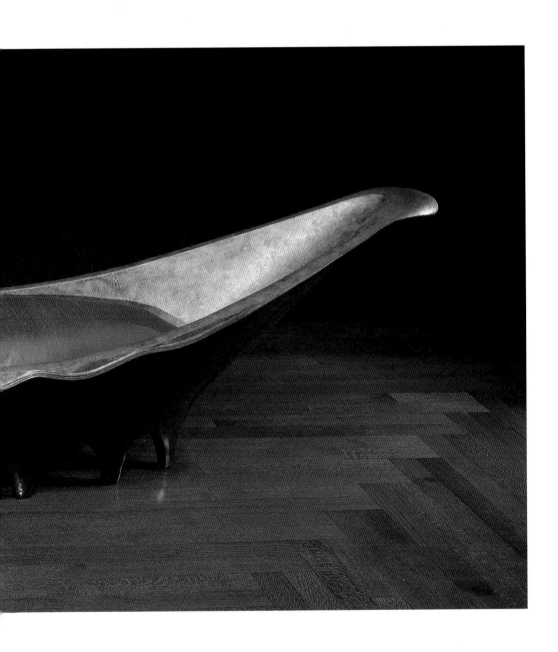

"Canoe" Sofa

EILEEN GRAY,
c. 1919–20; lacquered
wood, silver leaf, and
upholstery. Virginia
Museum of Fine Arts,
Richmond, Virginia.
Inspired by a native
African design, this
unusual canoe-shaped
lounge is both luxurious
and theatrical. The
black lacquered wood
accented with silver leaf
on the exterior contrasts
dramatically with the
crushed velvet uphol-
stery of the interior.

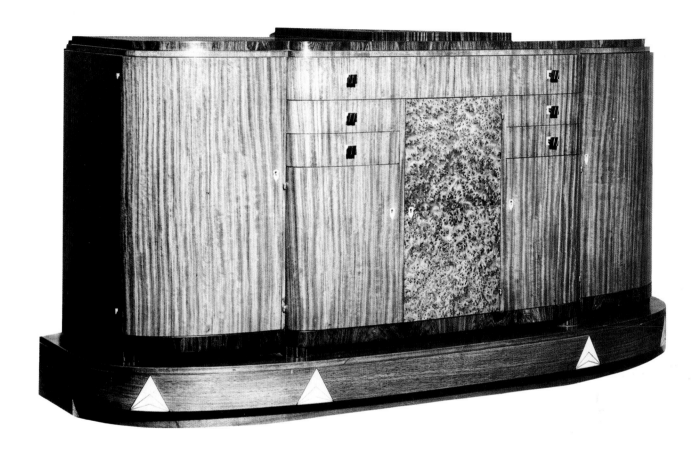

Buffet and Base

EUGÈNE SCHOEN, 1927; walnut, bubinga, imbua burl,
Macassar ebony, rosewood, and oak. Gift of the Modern Club
of Philadelphia (29–45-1), The Philadelphia Museum of Art.
Designed to conceal dining room clutter, this
buffet is a showpiece of rare and exotic wood veneers.
The neoclassical proportions of the piece relate to
German, French, and Viennese cabinetmaking traditions.

Vanity and Bench

Unknown designer—manufactured for Lord & Taylor,
New York City, c. 1931; red lacquered wood and chromium-
plated metal. Gift of Mr. James M. Osborn (1969.97A & B),
Cooper-Hewitt, National Design Museum, New York.
Oblique angles and slanted surfaces lend an unusual
presence to this red lacquer vanity and bench, which was
manufactured for a New York department store, and closely
copied from a French design. The shiny chrome hardware
adds to the dramatic contrasts and "Moderne" look.

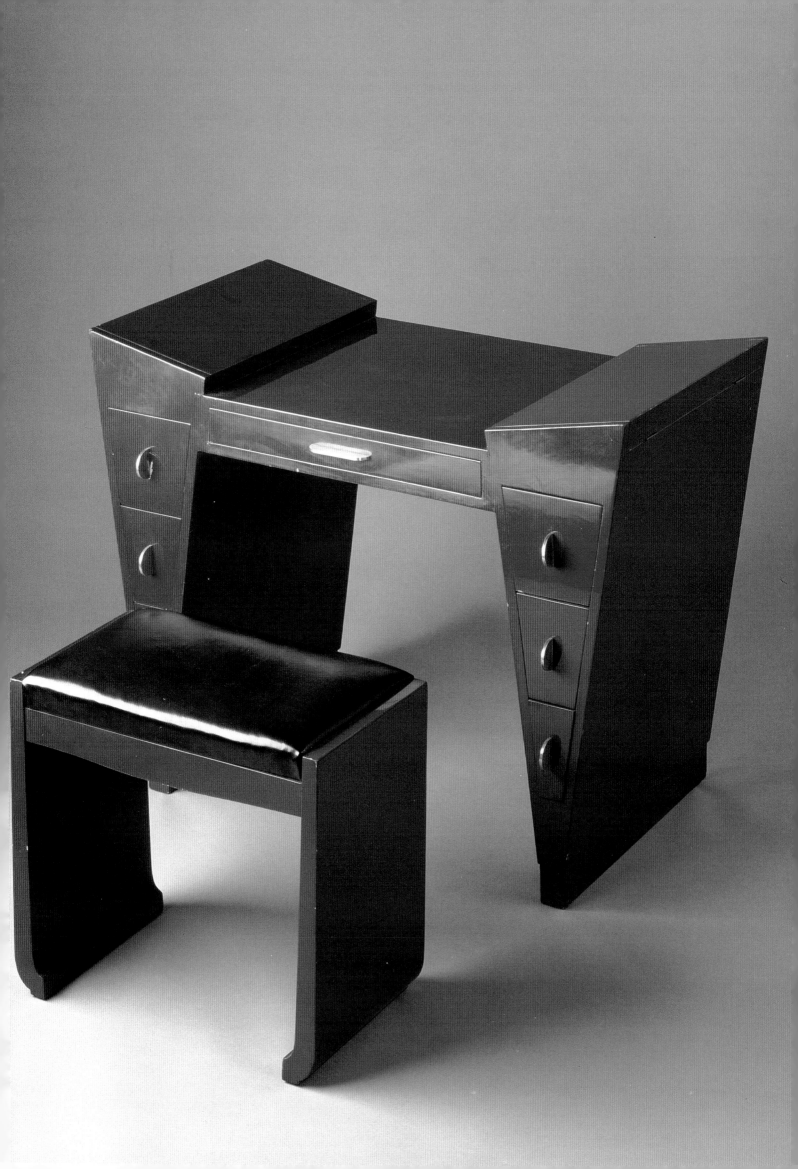

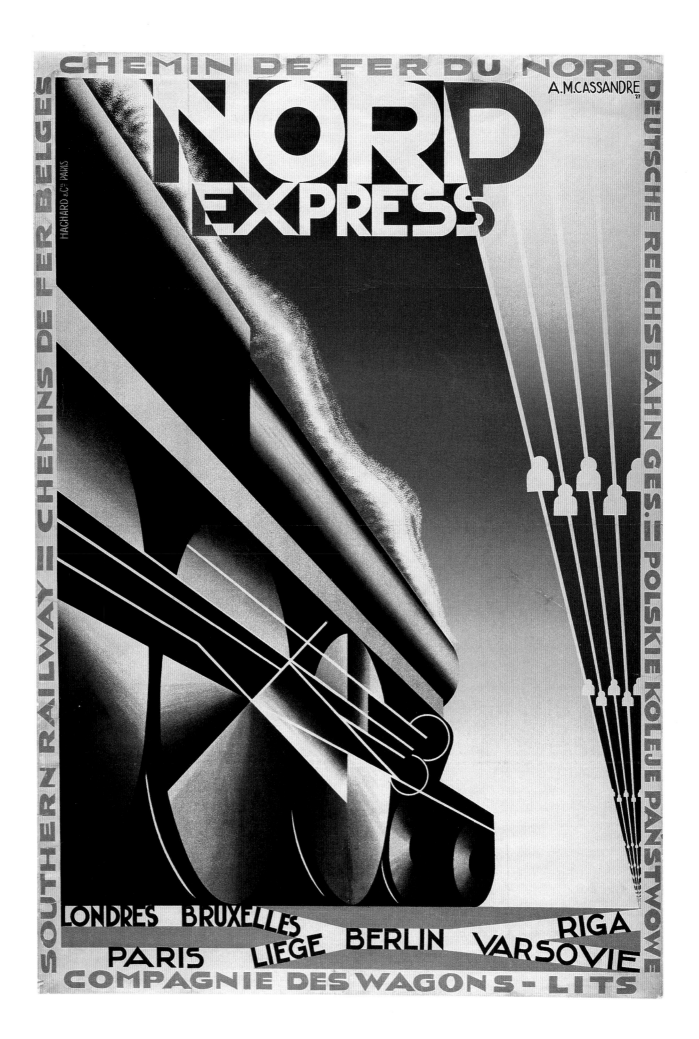

AN AGE OF FASHION

ot so long ago—in fact, up to the 1920s—there was no mass communication; no television, no radio, nor full-color printed advertising. (The first commercial radio station began broadcasting out of Pittsburgh, Pennsylvania, in 1920, and as technical improvements in the industry increased it was not long before the radio became a household fixture across the United States.) Newspapers and magazines were for the most part printed only in black and white and the colored lithographic poster was the most powerful form of commercial advertising in existence at the time. Then as now, of course, advertising responded to trends in design and absorbed the techniques being used to express the speed, sophistication, and urbanity of the era.

THE PRINTED ARTS

With the growth of advertising in the twenties, commercial art became, for the first time, a full-time profession. Graphic artists were able to draw on the rich poster tradition of the turn of the century for inspiration. Schulz-Neudamm's poster for *Metropolis*, a film by German director Fritz Lang, shows a robotic

looking person against the background of a futuristic city that evokes a claustrophobic mass of skyscrapers. This illustration suggests that the modern city could be nightmarish and dehumanizing and not, as was more popularly depicted, just a thing of glory and beauty. It contradicts Ruth and John Vassos' declaration (as stated in *Contempo: This American Tempo*, published in 1929) that "the skyscrapers . . . are probably the most perfect example of abstract beauty the world has had in generations."

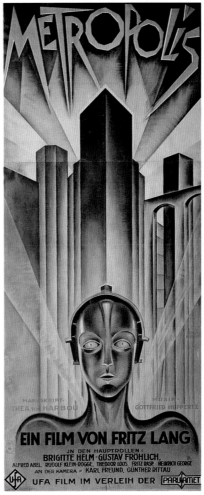

Nord Express

A. M. CASSANDRE, 1927; lithograph; 41 x 29 in. (104.1 x 73.6 cm). Gift of French National Railways, The Museum of Modern Art, New York.

A low viewpoint and raking perspective dramatize this monumental vision of a locomotive by one of France's premier Art Deco poster artists. The poster glorifies the speed and power of this modern travel machine with an optimism typical of the period.

Metropolis

SCHULZ-NEUDAMM, 1926; poster for a film by Fritz Lang; lithograph; 83 x 36 in. (210.8 x 91.4 cm). Gift of Universum \ Film \ Aktiengesellschaft, The Museum of Modern Art, New York.

The impression of life in the big city as frightening and dehumanizing is at odds with most Art Deco images— which glamorized modern urban life. Here, the geometric planes of monumental skyscrapers loom behind a blank-faced robotic figure rendered in bleak monochrome.

Adolphe Mouron Cassandre designed a series of striking posters for travel companies. In order to promote the virtues of travel by train and boat, he created powerful images of these icons of speed with strong light and dark contrasts and, when viewed from below, this caused the locomotive or steamship to look

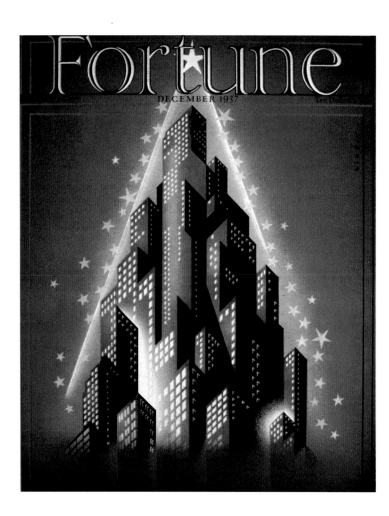

Fortune—Buildings in a City Forming a Christmas Tree

JOSEPH BINDER, December, 1937.

The pyramid is both the symbol of the modern city and the conical shape of a Christmas tree in this inventive visual pun. The modern stepped silhouettes of skyscrapers at night are suggested by the bright squares of their illuminated windows, while along the perimeter falls a cascade of golden stars.

positively monumental. British designer E. McKnight Kauffer, also interested in expressing speed and movement in the modern idiom, designed an untitled poster of birds in flight for *The Daily Herald*. Kauffer, like Cassandre, uses powerful light-dark contrasts. He also employs repetition and geometric fragmentation in the manner of the Cubists and the Futurists to express the birds' darting movements. An advertisement for *Salamander* shoes by Ernst Deutsch portrays three identical pairs of dancing feet, suggesting movement once again through repetition and strong contrasts, although here with a simplified and collage-like style.

Another way the Art Deco style found its way to the printed media was via magazine covers. *The New Yorker*, first published in February 1925, was an upscale entertainment magazine that featured artist-designed color covers. By 1925 the publication *Vanity Fair* had also become a gossipy, theatrical, and fashionable general entertainment publication. Of course Europe also had its share of Art Deco magazines: Italy had *La Rivista* ("The Review") and France *Le Rire* ("The Laugh") and *La Vie Parisienne* ("Parisian Life"), while the Art Deco style in Germany was seen on the covers of such magazines as *Die Woche* ("The Week") and *Die Dame* ("The Woman").

Rose Silver ("Lisa Rhana") became one of *The New Yorker*'s leading Art Deco cover artists, and her illustrations display the exaggerations and

Salamander

ERNST DEUTSCH, 1912; lithograph; 27³/₄ x 37⁵/₈ in. (70.4 x 95.5 cm). Gift of the Lauder Foundation, Leonard & Evelyn Lauder Fund, The Museum of Modern Art, New York.

Three pairs of identical shoes dance across this German advertisement in a notably flat design that highlights the name of the company and its distinctive, reptilian logo. Posters such as this, meant to convey their message from a distance, relied on strong, simple shapes and bold color contrasts.

contrasts typical of the style. Dancers with long streaming hair flowing in gravity-defying horizontal waves, women in speeding motor cars, and trains were among many popular cover subjects. Joseph Binder's December 1937 cover for *Fortune* shows a dramatic stepped pyramid of buildings that is also a star-topped Christmas tree—combining symbols of modernity with the spirit of the season.

Surveying the many examples of magazine cover illustration of the period, it is clear that Art Deco graphic works did not portray the real world but rather presented an interpretation of life as elegant, refined, and optimistic. The angular, sinewy women of Art Deco are very different creatures than the languid women of Art Nouveau. That Art Deco graphics offered a world of escapism is self-evident; they represented a reality that people desired, the showy, public, fantasy world of Hollywood musical extravaganzas—a sophisticated illusion—rather that the actualities of life in a world devastated by two world wars and a major economic depression.

The sloe-eyed model wearing a cloche hat in George Lepape's *Vogue* cover views the world with a withdrawn, snobbish expression that seems to say she has it all, and is perhaps a little bored with her trendy clothing and the glittering spectacle of the modern

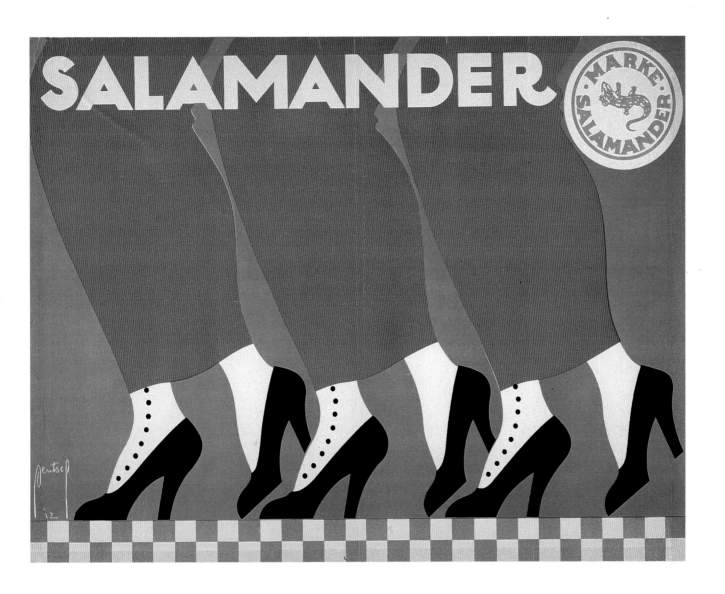

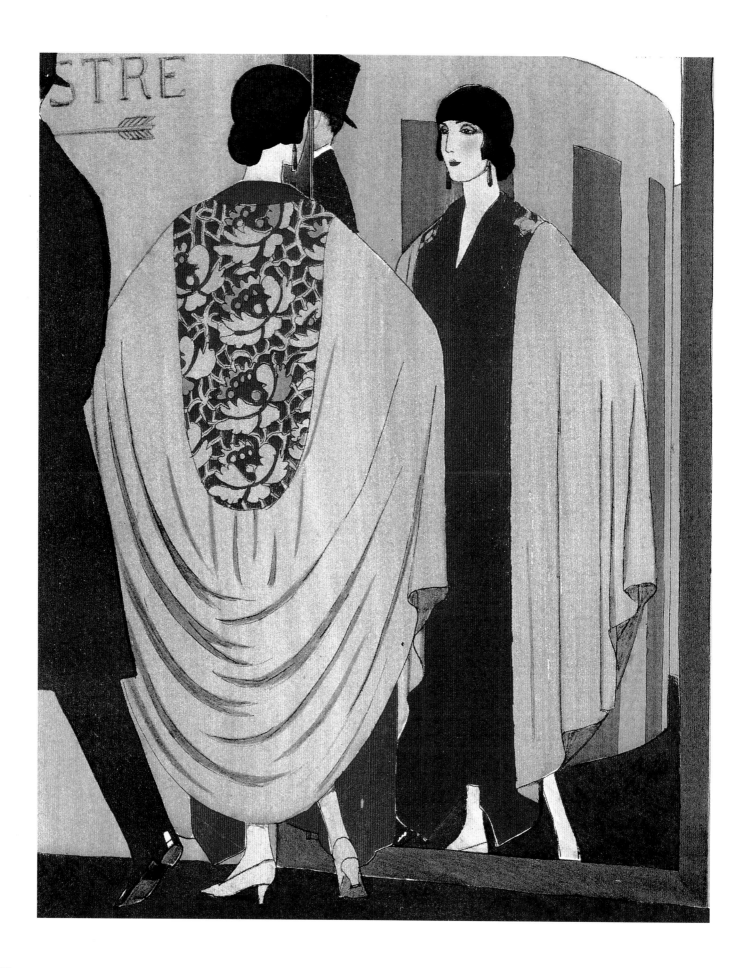

city behind her. Her face, like that of the fashionable lady holding her leashed greyhound in the park on Vladimir Bobritsky's cover for *Vanity Fair*, is blank and impersonal, so that every women can identify with the fantasy by imagining herself in her place. Like the sparkling skyscrapers, the sleek forms of borzois and greyhounds were popular Art Deco motifs as symbols of speed and modernity. As such a symbol, the greyhound was thus a highly appropriate choice as logo for the ubiquitous Greyhound buses that crisscross America.

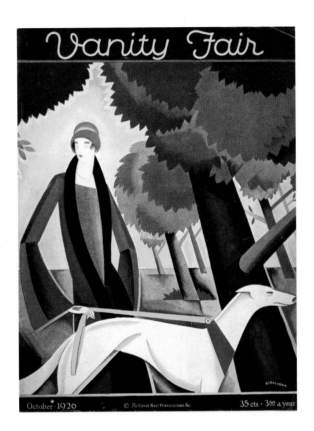

***Vanity Fair—*Fashionable Woman Walking Her Dog**

VLADIMIR BOBRITSKY, October, 1926.

The woman in this park scene is sleek and refined, as is her leashed greyhound, which gazes sternly off into the distance. The trees lean at an unsettling angle, crowned by zigzagging leaves, but the fashionable woman of leisure seems oblivious to any menace, implied or otherwise.

The designs of Paul Poiret upheld the ideal of the wealthy and fashionable modern woman, whether shown cavorting with a deer—another popular Art Deco motif—or clad in a fabulous cloak, on her way to the opera. Poiret's designs revolutionized women's fashions and were widely imitated. Louis Icart, another mythologizer of modern life, was a self-taught painter and printmaker who produced many paintings, lithographs, and etchings in the 1920s, mostly images of stylish, languid young women accompanied by their pet dogs. Illustrator George Barbier, too, produced many images of the modern woman living the good life, sometimes with more than a touch of satire. His work frequently appeared in Paris's best-known fashion magazines.

Cloak

PAUL POIRET, 1922; illustration for the Gazette du Bon Genre, *v. 6. Gift of Lee Limonson, 1949, Irene Lewisohn Costume Reference Library, The Metropolitan Museum of Art, New York.*

Poiret's top-hatted men and elegantly cloaked women entering the inner sanctum of the opera house offer a vivid sense of the style and mood of the Deco era.

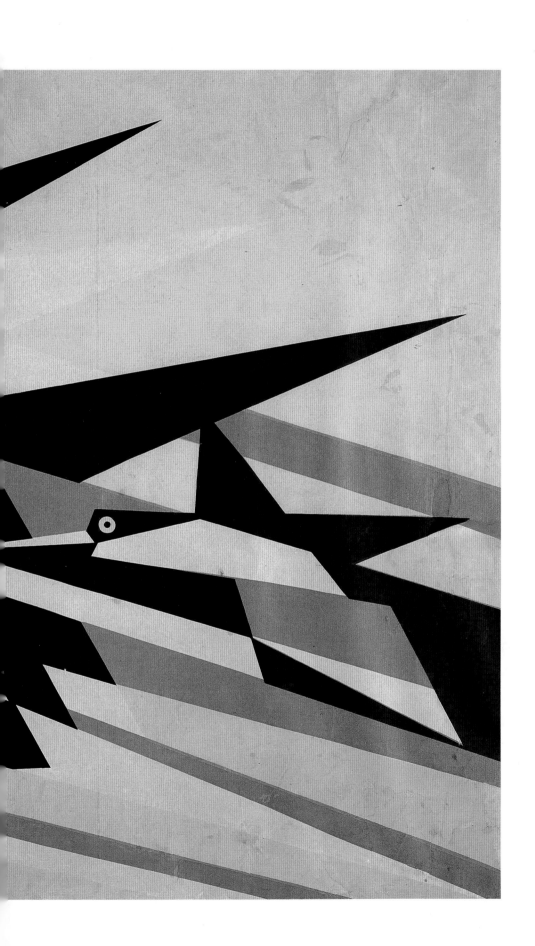

The Daily Herald

E. McKnight Kauffer, 1919;
lithograph; 39¹/₄ x 59⁵/₈ in.
(99.6 x 151.4 cm). Gift of
the designer, The Museum of
Modern Art, New York.
In this design the birds are
so abstract they are almost
unrecognizable, but when
the eyes and beaks make
their identity clear, the jagged
geometric shapes seem a
perfect expression of the
speed and motion of flight.

BOOKBINDING AND ILLUSTRATION

The art of bookbinding enjoyed a period of innovation during the Art Deco period. The revival was centered in France, and grew in part from the fact that at the time books were mostly printed with flimsy paper covers and collectors who could afford to do so generally commissioned leather bindings to be made to order so as to preserve their libraries. The traditional craft of bookbinding had been shaken up by the Art Nouveau style, and it took the efforts of a young furniture designer, Pierre Legrain, to bring the Moderne style to book covers. Through a commission from a former decoration client, Jacques Doucet, and without prior experience in the field of book design, Legrain began to create covers for works in Doucet's collection of contemporary literature.

Doucet was so pleased with the results of Legrain's efforts that he commissioned more bindings from him and word of his innovative work soon spread within the clubby world of book collectors. Not having been trained in the traditional arts of bookbinding, Legrain felt free to experiment with Moderne motifs and materials, including the luxury materials used in avant-garde cabinet-making. To the traditional material of Moroccan leather, the new style of bookbinding added embellishments that employed a wealth of materials: snakeskin, vellum, inlays of colored leather, fillets of precious metal, paint, lacquer, enamel, bronze, ivory, mother-of-pearl, tortoise-shell, and semi-precious stones.

Morocco Binding for Colette's *Chéri*

ROSE ADLER, 1931; 11 x 9 in. (27.9 x 22.8 cm). Gift of Sydney and Frances Lewis, Virginia Museum of Fine Arts, Richmond, Virginia. Adler was one of the masters of the revival in book binding that occurred in France during the Art Deco period. Here she creates a boldly modern design using large and small gold circles against a background of red Morocco leather with black accents. The sans-serif lettering is integral to the design— the "C" in the title forms the large half circle, while the vertical forms of the "H", "R," and "I" are used to punctuate the design.

Advances in typography, in particular the development of sans serif's distinctly modern face, also contributed to the new look of bookbindings. A decade earlier, the Russian Constructivists had been the first to evolve type into an abstract element of design. The Futura and Broadway fonts are typical of the precise angularity and geometric quality of the Deco style. Indeed, the geometric shapes of the letters themselves, now unencumbered by those little finishing strokes and flourishes known as "serifs," became integral to the design of this new generation of bookbinding. Unique book cover designs abounded, and Paris was, as usual, at the center of the new movement. Rose Adler, Georges Cretté, Paul Bonet, François-Louis Schmied, Lucien and Henri Creuzevault, Georges Canape, and Robert Bonfils were among the most talented of the binders, and the movement also attracted the talents of graphic artists such as Maurice Denis, George Barbier, and Georges Lepape as well as fine artists.

Pockets of innovation in bookbinding also arose in the United States. Jean Eschmann taught bookbinding classes at the Cranbrook Academy and his style is clean and spare, relying on streamlined forms, geometry, multiple colors, and modern typefaces as an integral part of the design. John Vassos' elegantly geometric cover for *Contempo* is another distinctive example of American bookbinding. The integrated design of arcing curves, parallel straight lines, and bold type style are stamped in silver, set off against a deep blue linen cover.

Contempo also offers interesting examples of Art Deco book illustration, such as a male nude, which is both stylized and monumental, classical yet dramatically modern. The accompanying text is typical of the Vassos' opinionated cynicism: "Crown the victor with gold, give him a vaudeville contract, sent him to Hollywood. Offer him no more the laurel, but the front page and the big money." This slim volume, divided into short sections of text, each accompanied by an illustration, reflects many of the preoccupations of the era between the wars—a love affair with machines

("there is a precision and beauty in the machines that man must keep up with") and the subway ("speed under the earth"); an admiration for modern communication ("the great god RADIO spans the earth"); and a profound cynicism about people and politics as well as frightening and prescient anti-Semitism. Rockwell Kent, an American painter, writer, and graphic artist, created illustrations in the Art Deco style which are notable for their stark, powerful impact. Kent's wood

The Flame

ROCKWELL KENT, *1928; engraving. Dudley P. Allen Fund,*
The Cleveland Museum of Art, Cleveland, Ohio.
Strong contrasts and a bold graphic style distinguish the
Art Deco illustrations of this American artist. Kent's work
combines the optimism of Art Deco with a timeless classicism
often found in monumental sculpture of the period.

engraving *The Flame* displays bold contrasts and a sculpturally classical male nude which relates his work to *Contempo*.

PAINTERS

Art historian Alastair Duncan maintains that it is difficult, if not impossible, to define painting between the wars in an Art Deco context. Most artists were using Cubist-derived techniques, elongation, or bright colors, and many were simplifying forms to the point of semi-abstraction. Art Deco painting was generally derivative—that is, not at the vanguard of modern art movements—and also decorative, or designed to fit in with overall modern decorating schemes. Jean Dupas, for example, favored decorative subjects of idealized women, while Jean Lambert-Rucki worked in a style inspired by African art and Cubism.

The paintings of Polish-born Tamara de Lempicka, dominated by fashionable portraits and semi-erotic nudes, are also considered typically Art Deco. The artist's portrait of her daughter, *Kizette on the Balcony* (1927), is typical of the way she modeled forms with energetic lights and darks. De Lemipicka first began painting in order to support herself and her daughter after being deserted by her husband. While living in Paris, she achieved a good deal of success as a portraitist in swanky circles. Her work later fell out of fashion, although it lately has seen a revival of interest, thanks in part to her daughter's efforts. De Lemipicka had a feeling for her portrait subjects and an appealing technique that drew from Synthetic Cubism as well as her admiration for the nineteenth-century academic painter Jean Auguste Dominique Ingres. Her manner of painting is summed up by her assertion, in keeping with the machine age, that a painter has to "mind the precision. A painting has to be neat and clean."

Another Art Deco artist who was influenced by Cubism and the machine aesthetic was American textile designer Ruth Reeves. The impact of Reeves' association with Modernist painter Fernand Léger is apparent in her silk-screened images, such as one done on the subject of three women at a luncheon, compared stylistically with Léger's painting *Three Women*.

**Kizette on
the Balcony**

*TAMARA DE LEMPICKA,
1927; oil on canvas. Musée
Georges Pompidou, Paris.*
The artist's daughter is
rendered in a sensual
style, her rounded forms
strongly modeled in
light and dark. Over
the balcony, a view of
Paris is fragmented
into Cubist planes that
attest to the Modernism
of the portrait.

Standing Floor Lamp

*WALTER VON NESSEN, c. 1928; brass and iron. Enoch Vine
Stoddard, B.A. 1905, and Marie Antoinette Slade Funds
(1982.5), Yale University Art Gallery, New Haven, Connecticut.*
The dramatic effect of light bouncing off the ceiling from this
torchère-style lamp may have been suggested to the designer by
indirect theatrical lighting. The fluted lamp pole evokes a neo-
classical column, but the metal disks and the flaring sections of the
shade recall the forms of modern machinery. The use of chromium,
a new material, was also popular in achieving the machinelike effect.

INTERIOR ILLUMINATION

Just as the night skyline was dramatized by the sil-
houettes of the new skyscrapers, interiors also de-
manded a new kind of lighting suited to the
modern era. Art Deco lighting relied on techniques
that sculpted electric light and emphasized its
milkiness and limpidity rather than the potential to
create and transform color, as had the Art
Nouveau–styled lamps. The malleability of glass, a
medium in itself symbolic of modernity, allowed
etching, enameling, sandblasting, pressing, and en-
graving as decorative techniques which achieved
both surface decoration and sculptural effects.
Alabaster, too, was used for its milky translucence.
Mounts were frequently made of shiny metal;
chromium, aluminum, and steel replaced bronze as
favored materials. Examples of this style include
Walter von Nessen's standing floor lamp, with its
stepped silhouette echoing the architecture of the
period or even the forms of machine-made prod-
ucts, and American designer Donald Desky's table
lamp, which has the linear geometry of avant-garde
painting.

In the 1920s designers finally started to let go of
the form of a light fixture which mimicked candle
holders or gas jets and began creating more mod-
ern forms to encase the light bulb. In Europe, Jean
Perzel was an innovator in modern lighting, as
were Edgar Brandt, the firm of Daum, Albert
Simonet, Maison Desny, Albert Cheuret, Lalique,
Süe et Mare, and the Parisian department stores Au
Bon Marché and Primavera.

Table Lamp

*DONALD DESKEY, 1926–27; glass, chromium-plated
brass, and wood. Gift of Theodore R. Gamble, Jr.,
in honor of Mrs. Robert Gamble, 1982 (1982.33),
The Metropolitan Museum of Art, New York.*
The diagonal linear design on this lamp relates
to Dutch avant-garde painting of the period, while
the fluted base suggests the influence of the neo-
classical tradition. The linear, boxy handling of
glass and chrome gives the lamp its modern look.

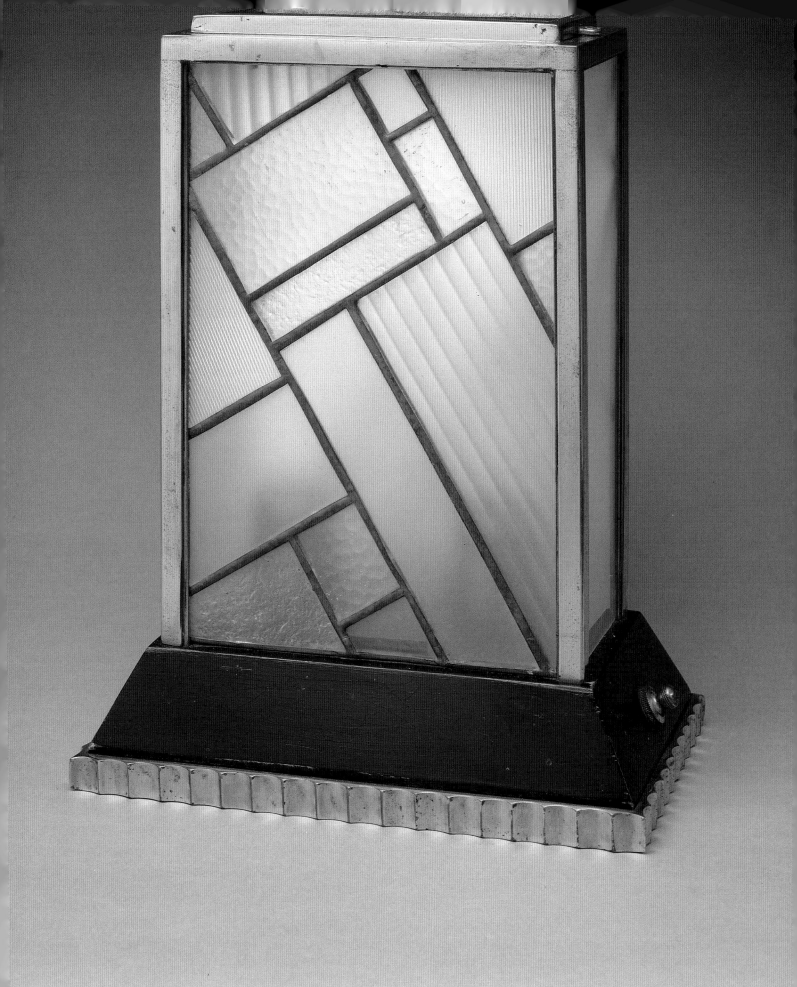

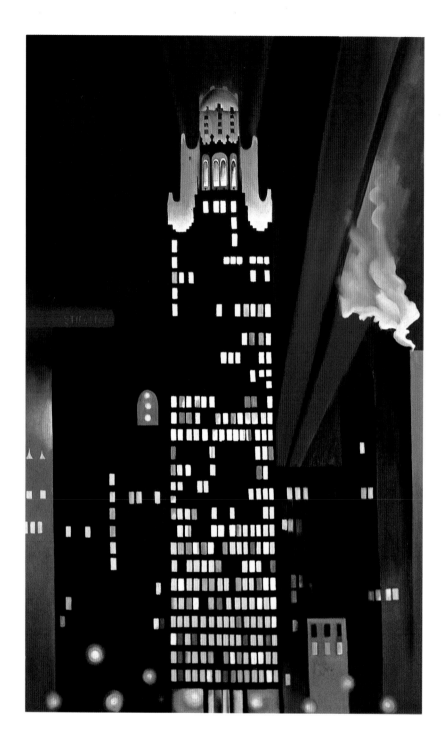

Radiator Building—Night, New York

GEORGIA O'KEEFFE, 1927; oil on canvas, 48 x 30 in.
(121.9 x 76.2 cm). Alfred Stieglitz Collection, Carl van Vechten
Gallery of Fine Arts at Fisk University, Nashville, Tennessee.
O'Keeffe records the essence of New York at night in this stark
painting—remarkable for its simplicity and the way the different light
effects are rendered, from haloed street lamps to shining spotlights
capturing a curl of smoke. The neo-Gothic Radiator Building, with
its black brick and contrasting terra-cotta crown, is defined mostly
by the grid of lighted windows that mark its towering form.

STEPS TO THE SKY

The skyscraper was not a new architectural development in the 1920s but in New York it did acquire a new look thanks to the 1916 zoning code, which instituted required roof set-backs in order to try to preserve a modicum of light and fresh air in the rapidly growing city. These mandatory set-backs created a new profile for the modern building, a profile with an irregular stepped quality that caused architects of the period to look for inspiration to the monumental stepped architecture of the ancient civilizations of the Mayans, Aztecs, and Mesopotamians. In its turn, the form of the modern skyscraper and, in particular, the way it changed the city skyline came to be source of inspiration and fascination to artists of the period as they discovered and revealed a breathtaking beauty in the urban landscape.

Swedish-born Lillian Holm, a designer and weaver, came to the United States late in 1929 and began a career as a weaver and instructor at Cranbrook that lasted over thirty years. Her woven hanging, *First Sight of New York*, captures her first impression of the city of skyscrapers. Holm not only portrays the buildings, she includes a border filled with people in attitudes of wonder and awe looking inward from each side. She created a brightly colored weaving in a geometric style that relies on symmetry and forceful contrast for its striking effect. Textile artist Lydia Bush-Brown also created a silk batik wall hanging recording an impression of Manhattan. She illustrates a view across the harbor, with boats in the water, skyscrapers towering above a line of apartment buildings, and factories releasing great curling plumes of smoke.

American painter Georgia O'Keeffe lived in New York City for a time and, although she had reservations about the experience, she did find inspiration in its sky-

scrapers. O'Keeffe's *Radiator Building—Night, New York* (1927) depicts the neo-Gothic building, now the American Standard Building (designed by Raymond M. Hood and completed in 1924), in all its nighttime splendor. The slender black brick bulk is defined primarily through a grid of lighted windows, while its gleaming spotlit gold terra-cotta crown gleams in the night. O'Keeffe said of the work: "I walked across 42nd Street many times at night when the black Radiator Building was new—so that had to be painted, too."

John Storrs, an American, primarily expatriate, sculptor and favorite student of the great French sculptor Auguste Rodin, also responded to the forms of skyscrapers with his abstract series *Forms in Space*, which includes a piece entitled *New York*. Working with a combination of metals and wood, Storrs distilled the modern building to its essence, creating a vertical tower striped with contrasts and decorated with zigzags. Storrs enjoyed a successful career, although he never recovered from the ordeal of imprisonment in a concentration camp during the Second World War. He also worked in a streamlined figurative mode, as can be seen in the austere allegorical stone figure *The Legislative Branch*, which he designed for the United States Government Building at the 1933 Chicago World's Fair.

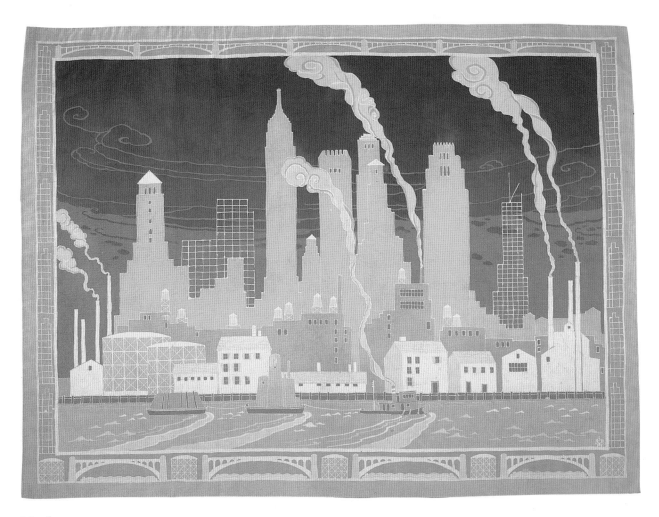

Manhattan

LYDIA BUSH-BROWN, c. 1929; silk batik. Cooper-Hewitt, National Museum of Design, New York.

A dramatic skyline is punctuated by curling plumes of smoke in this decorative batik. The designer has captured with charm and originality the feeling of overlapping layers of the city's buildings, the squat water towers, and the busy harbor. The image is framed by a border of semi-abstract bridge spans and buildings.

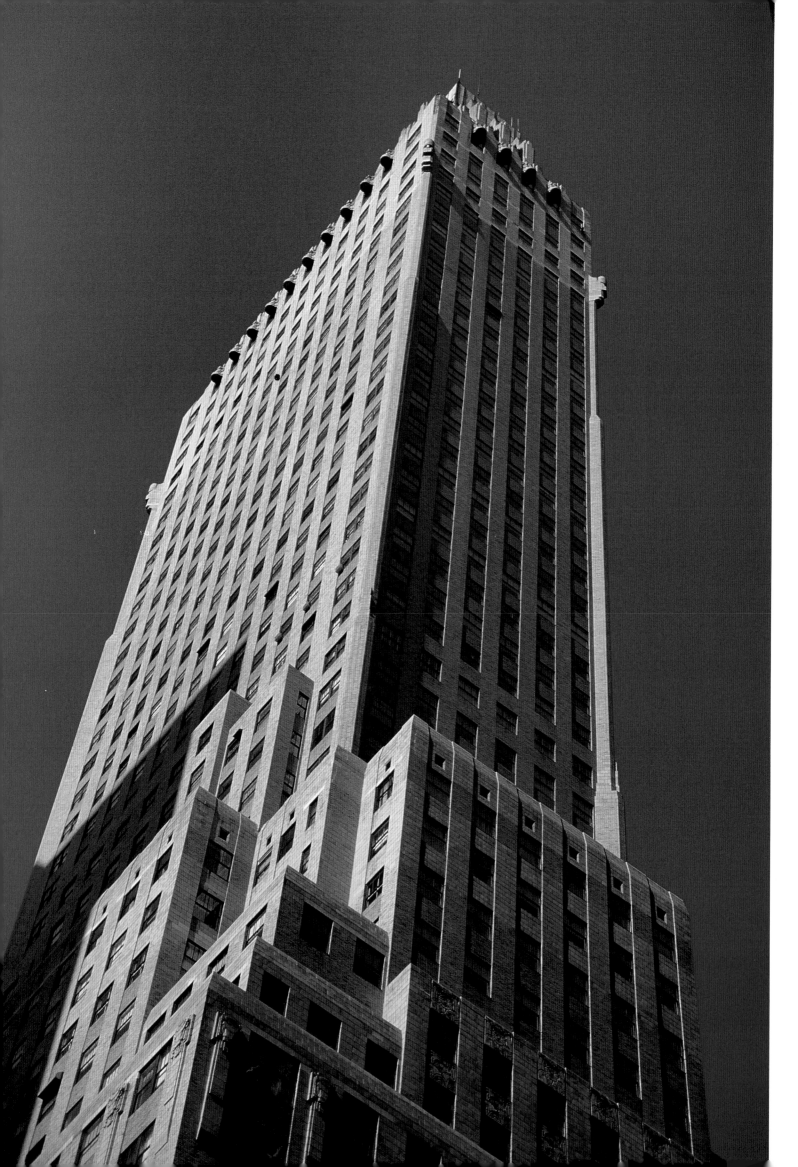

SKYSCRAPERS

The drive for height and distinctive ornamentation distinguished the new breed of skyscrapers and made them stand out from the previous generation of tall buildings. The forms of these buildings, which began to rise in the late 1920s and early 1930s, are the most notable historical legacy of Art Deco to the present time. Skyscrapers, such as the recently completed Liberty Place in Philadelphia—inspired by New York's Chrysler Building—are still being built in their image.

The technical means to build tall buildings—steel construction and reinforced concrete—had already been mastered by the time Art Deco–inspired skyscrapers appeared, and it was the terraced silhouettes and nonstructural decorative elements that made New York skyscrapers Art Deco, not their height, materials, or innovation. There was nothing particularly new about their interior structures, floor plans, or services. As art historian Patricia Bayer notes, "Art Deco architecture was an architecture of ornament, geometry, energy, retrospection, optimism, colour, texture, light, and at times even symbolism."

The first Art Deco building to rise in Manhattan was Sloan and Robertson's Chanin Building, built for architect and developer Irwin Chanin. At 680 feet (207 meters), it came in just 112 feet (34 meters) shy of the 792-foot (242-meter) Woolworth Building—an imposing neo-Gothic structure in downtown Manhattan that had the distinction of being the world's tallest building from 1913 to 1930. The Chanin Building had more floors than the Woolworth Building and a prominent location in a developing area of midtown Manhattan, the corner of 42nd Street and Lexington Avenue—right near that hub of modern transportation, Grand Central Station.

The Chanin Building

SLOAN AND ROBERTSON, 1929. New York City.

The slender slab and stepped profile of this modern

skyscraper was necessitated by New York zoning codes.

However, the rich angular and floral decoration, found through-

out the interior and exterior, were pure Art Deco fantasy.

Facade of the Chanin Building

SLOAN AND ROBERTSON, 1929. New York City.

The highly ornamental facade of the Chanin Building has a base ornately decorated with terra-cotta reliefs in a swirling stylized floral motif.

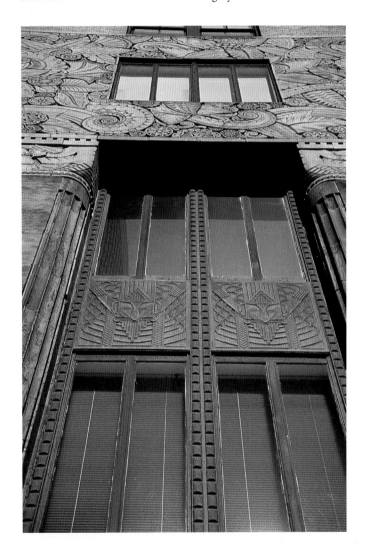

The Chanin Building is a squarish tower that stretches into a slender slab with the required stepped set-backs. The base is ornately decorated with terra-cotta reliefs in a swirling stylized floral motif; the lobby, designed by Jacques Delamarre, has elaborate radiator grilles with a pattern representing the exterior of the building surrounded by a sky of vibrant lines suggesting electrical energy. The original executive suite, also designed by Delamarre, had a tiled bathroom that was an opulent Art Deco fantasy, with

geometric designs, sunbursts, pyramids, and papyrus forms adapted from ancient Egyptian art.

Before long, the Chanin Building was upstaged by the Chrysler Building, designed by William Van Alen and completed in 1930. At 1,048 feet (320 meters) to the top of its spire, and seventy-seven stories, it became the world's tallest building for a few months, before the completion of the Empire State Building. As a flamboyant presence on the skyline, the Chrysler Building made its mark; its crowning tower of stepped-back arches, with triangular windows arranged like sun rays, gleams during the day from its coating of stainless steel—one of the first examples of the use of stainless steel over a large exposed building surface. At night its florescent crown glows bright, illuminating the distinctive design and creating an unforgettable symbol and spectacle.

The Chrysler Building is also an emblem of the

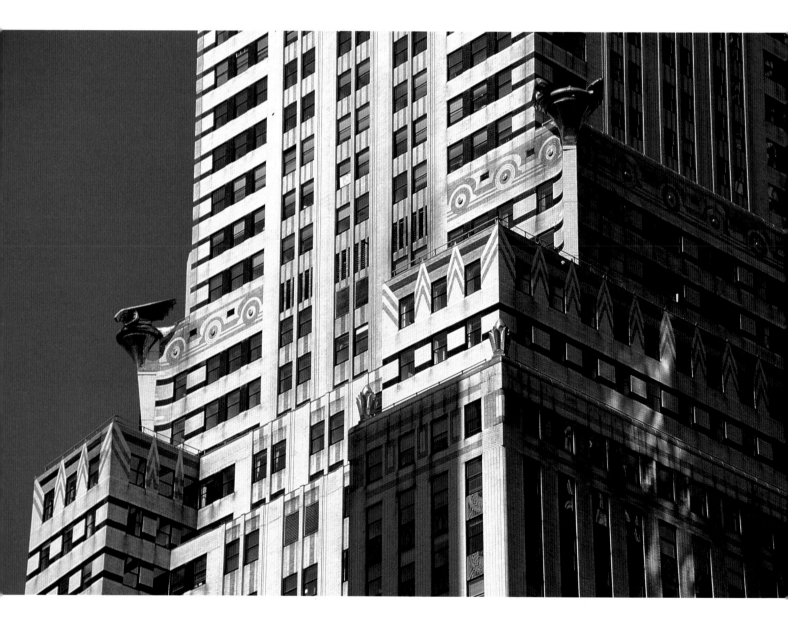

The Chrysler Building

WILLIAM VAN ALEN, 1930. New York City.

Enormous hood-ornament gargoyles and a frieze of abstract cars, as well as the metallic look, make reference to the Chrysler automobile company, resulting in an unforgettable monument to the machine age.

Chrysler automobile, a personal project of automobile magnate Walter P. Chrysler. The shining metal of its exterior includes not only story-high basket weave designs but also enormous hood ornament gargoyles and a band of abstract automobiles. The lobby is resplendent in a combination of deep red African marble and silvery chrome steel; of particular interest are the striking wood-veneer elevator doors in a quasi-Egyptian papyrus motif which echo, in reverse, the building's zigzag spire. The body of the building itself is of white brick with gray brick ornamental trim and lines that emphasize both the towering vertical and the jazzy contrasting horizontal elements. The theatrical and fantastic design of the Chrysler Building encourages an emotional response—it reflects the optimistic and dramatic mood of Art Deco, a design that at the moment of its conception was truly original.

The top spire of the Chrysler Building was an afterthought. The original plans called for a 925-foot (276-meter) height but in the craze for "taller" that gripped the city, Van Alen added the spire to make sure his building was the tallest. Yet before the Chrysler Building was completed, construction was under way at 34th Street and Fifth Avenue on the Empire State Building, designed by the firm of Shreve, Lamb and Harmon according to the design of William F. Lamb. Completed in 1931, the Empire State, at 102 stories and 1,250 feet (381 meters), became in its turn the world's tallest building, a title it was to retain until the completion of the twin 1,350-foot (412-meter) World Trade Center towers in the seventies.

Planned during the booming twenties, but built during the Depression, the Empire State Building had trouble filling its copious office space during its early years and the joke was that the building relied on the stream of sightseers it attracted to pay its property taxes. Lamb was known for his straightforward commercial designs; his plan for the Empire State Building was the simplest solution he could conceive to apply the zoning codes and please the backers, John J. Raskob and Pierre S. duPont, together with former Governor Alfred E. Smith, who wanted a large building, not necessarily a distinctive one. The result was more restrained than the Chrysler Building, but with a

simple streamlined dignity, nicely proportioned rhythmic set-backs, and a gently rounded tower, the Empire State Building endures as a symbol of New York urban modernity. This massive edifice relies less on ornament and more on profile for its impact. It has a grand entrance on Fifth Avenue and modernistic stainless steel canopies on its side entrances, but in general its street-level impression belies the drama of its silhouette viewed from afar.

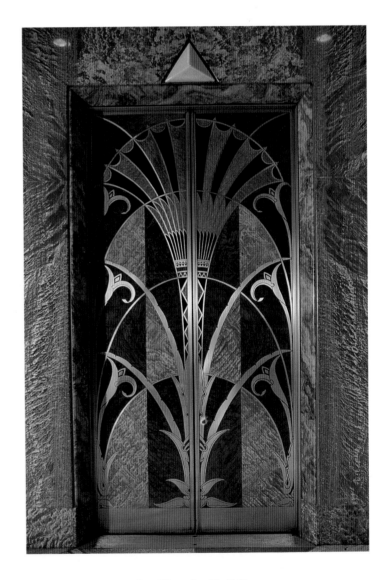

Elevator Doors in the Chrysler Building

WILLIAM VAN ALEN, 1930; veneers by the Tyler Company.

A fantastic Egyptian papyrus motif adorns this most unusual elevator door, the showpiece of a lobby decorated in red African marble and chrome steel. The design also echoes the spire of the building in its stacked arches and triangular motif.

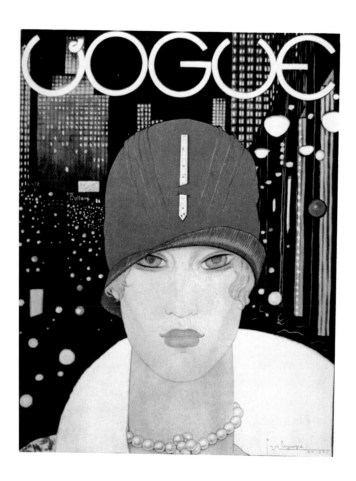

Vogue—Woman in a Cloche Hat

Georges Lepape, March 15, 1927.

A woman of fashion in a cloche hat looks out from this
magazine cover with all the glory of the lights of Manhattan
behind her. Her large, blank eyes and bored expression suggest,
however, that she is already somewhat jaded by her glamorous life.

Forms in Space

*JOHN STORRS, c. 1924; aluminum,
brass, copper, and wood on a black
marble base; 28¾ in. high (73 cm).
50th Anniversary Gift of Mr. and
Mrs. B. H. Friedman in honor
of Gertrude Vanderbilt Whitney,
Flora Whitney Miller and Mlor
Miller Biddle, The Whitney
Museum of Art, New York.*
Storrs communicates the abstract
essence of the skyscraper in
this metal and wood sculpture,
wherein the sheer verticality
of the form is enhanced by a
strong play of light and dark and
a zigzag running up the side.

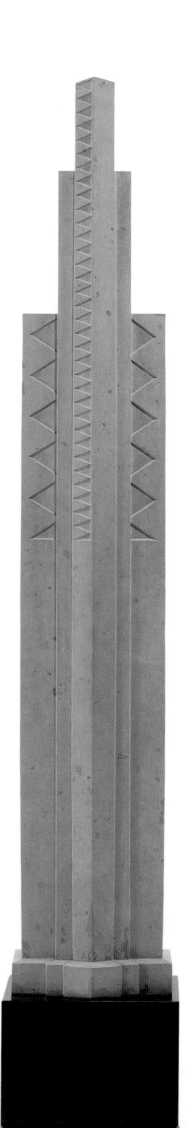

Following page:

Facade of the Chanin Building

*SLOAN AND ROBERTSON,
1929. New York City.*
Detail of a decorative
panel from the facade of
the Chanin Building.

Vanity Fair—Dancing Woman

Synton G. Rimki, January, 1929.

This dancer is frozen in an almost Egyptian pose while her long
hair streams out horizontally, giving the impression of speed
and motion. Her figure is both stylized and idealized—enhanced
by the soft blues, roses, lavenders, and greens of the composition.

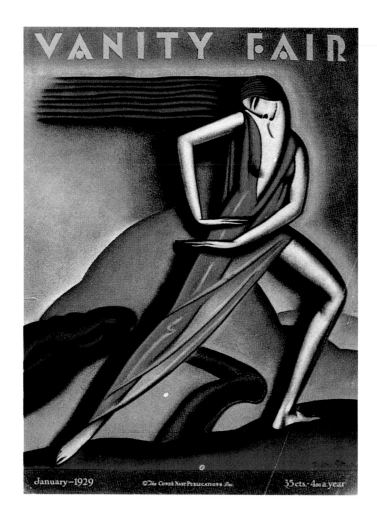

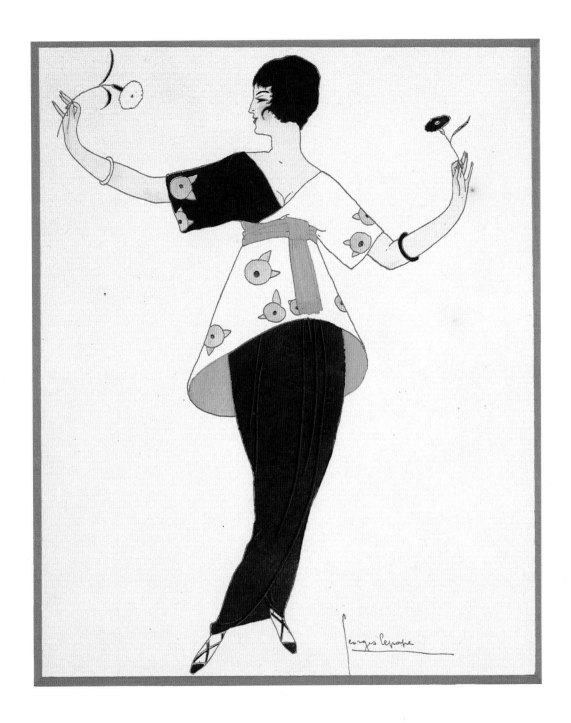

Laquelle?

GEORGE LEPAPE, 1913; plate 5 in September 1913 Gazette du Bon Ton.

Gift of the Costume Committee, Hope B. McCormick Costume Center, The Chicago Historical Society.

A gifted illustrator, Lepape translated the fashion designs of famed couturier Poiret

into exotically tinged drawings that captured perfectly the stylized elegance of the period.

Sports

JOHN VASSOS, 1929; illustration from
Contempo *by John and Ruth Vassos.*
Vassos uses a low viewpoint, familiar
from A. M. Cassandre's posters, to
create a feeling of monumentality
in this male nude, while the text
comments cynically on the com-
mercialized state of modern sport.

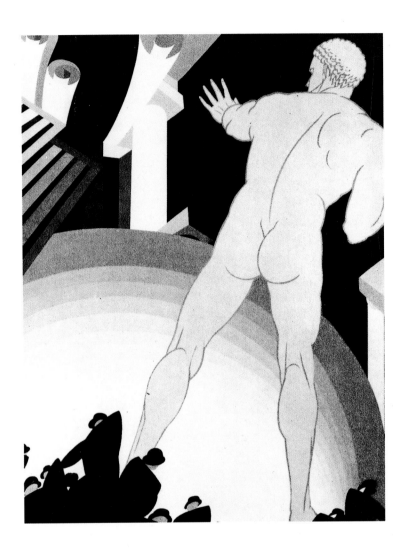

Binding for the *Odyssey* of Homer

JEAN ESCHMANN, 1931; tooled leather; 13³/₈ x 9⁵/₁₆ in. (33.9 x 23.6 cm).
Cranbrook Academy of Art Library, Bloomfield Hills, Michigan.
This attractive binding is enhanced by straight-line rules of gold tooling
which create a frame of rectangles around an inset of colored leather.
The central motif is an abstract interlace of zigzag geometric forms.

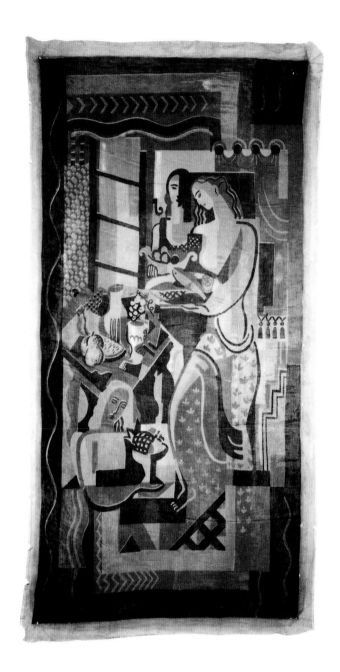

Three Women

RUTH REEVES, c. 1930–35; silk-screen print on cotton. Cooper-Hewitt Museum of Design, Smithsonian Institution, New York.

The artist's debt to French Cubism is apparent in this lyrical silk-screen which has many stylistic similarities to paintings by Léger, with whom Reeves was associated. However, Reeves' interpretation of the subject of three women and their luncheon is infused with a graceful lyricism that owes perhaps more to the supremely decorative work of Henri Matisse.

The Empire State Building

SHREVE, LAMB, AND HARMON, 1931. New York City.

Once the tallest building in the world, the Empire State Building is both a symbol of the modern city and a simple, elegant solution to the requirements of the New York Zoning Code. Its massive tower is well-proportioned and topped by a gently rounded spire that reaches 1,250 feet (381 meters) into the air.

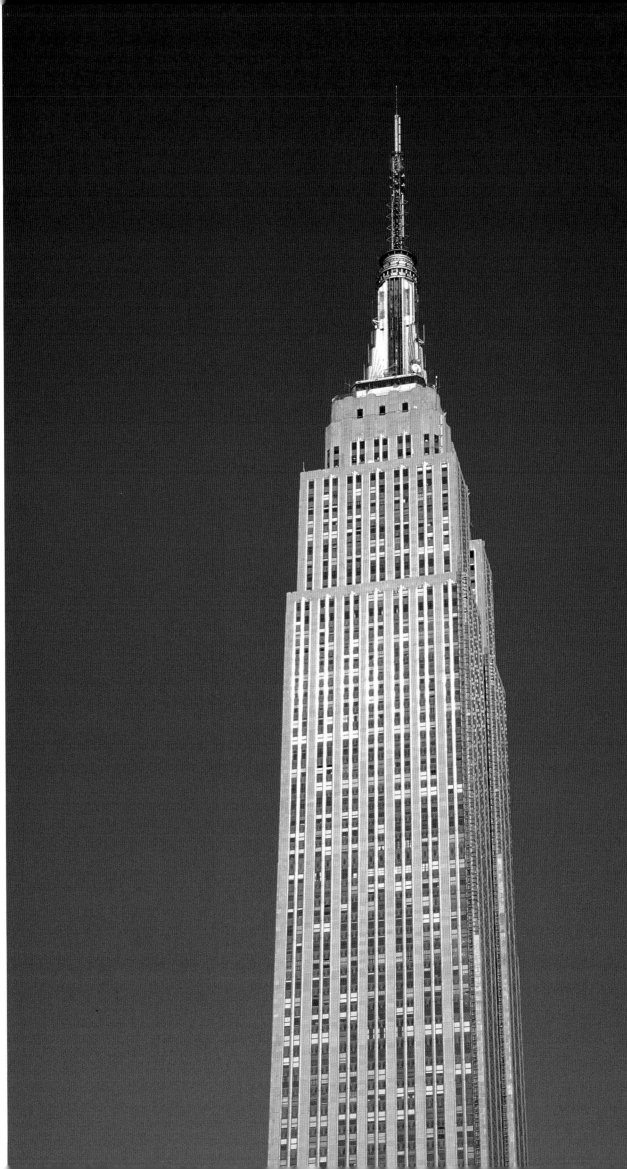

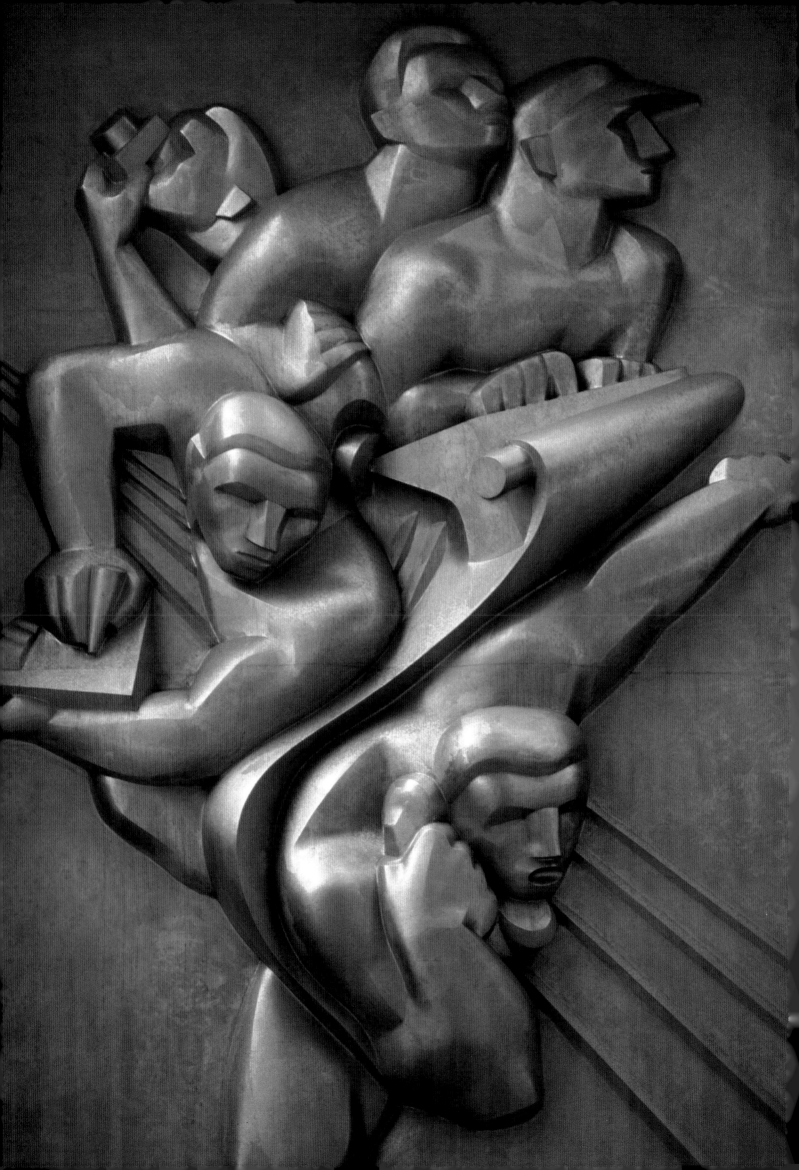

BUILDING THE FUTURE

The radically new and experimental look of the pavilions at the 1925 Paris Exposition was possible because these buildings were temporary structures, destined to be torn down once the Exposition finished its six-month reign, and also because the charter of the Exposition challenged exhibitors to show work of new inspiration and originality. However, aside from a few redone commercial facades, the new look in architecture did not have much impact in Europe outside of Paris. Europe was still recovering from the devastation of the First World War, and there was no major construction trend.

The United States, however, experienced a construction boom in the 1920s; skyscrapers as well as many forms of public, commercial, and to a lesser extent domestic structures were built in the popular Art Deco style. During the depression that followed the stock market crash of 1929, government programs such as the Work Projects Administration (WPA) supported the construction of many Art Deco projects. Fair pavilions and decorations, such as those of the Century of Progress Exposition in Chicago (1933–34), the Golden Gate International Exposition on San Francisco's Treasure Island (1939), and the World's Fair in New York (1939–40), were also built in the Art Deco style.

News

ISAMU NOGUCHI, 1938–39; stainless steel plaque; 20 x 17 ft. (6.1 x 5.1 m). Associated Press Building at Rockefeller Center, New York.

The optimism of man in the machine age is expressed by the muscular figures of these idealized newsmen who answer phones, take notes, snap pictures, and run the presses on the gleaming metal relief. The choice of subject also reflects the function of the building.

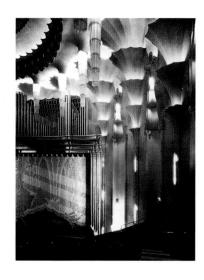

Interior Lighting of the New Victoria Cinema

E. WAMSLEY-LEWIS, 1930. London.

The interior of the theater is graced with unusual and dramatic lighting. The Egyptian-style pillars flare upward in fluted segments that are lit from within; other lights descend at intervals from the ceiling like crystal telescopes.

In England, the geometric decorations in the late style of architect Charles Rennie Mackintosh are consistent with Art Deco decoration. In the United States and elsewhere, from Argentina to Australia, the Art Deco style was considered appropriate for the construction of new building types—structures symbolic of modern life—and public works such as movie theaters, airports, power stations, fast food restaurants, department stores, suspension bridges, dams, tunnel entrances, post offices, schools, piers (and ocean liners), motels, and the headquarters and factories of modern businesses. The Art Deco style proved its versatility in the creation of lavishly ornate structures that symbolized in one way or another the power of their builders or, in the case of movie theaters, the dreams and aspirations of the patrons. The Art Deco style also lent itself well to the grandeur of fair pavilions, public sculpture, and public works. Yet Art Deco was equally effective in communicating the streamlined modernity of the gas station, the roadside diner, or the small commercial establishment, as well as of apartment buildings and domestic interiors.

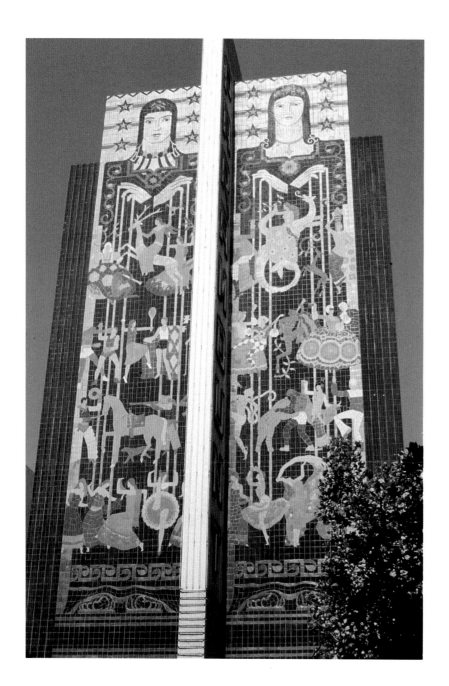

Tile Murals of the Paramount Theater

TIMOTHY PFLUEGER, 1931. Oakland, California.
Colossal puppet-masters hold the strings
of a multitude of people and many different
forms of entertainment vie for attention in
this colorful design depicting boxers, cowboys,
hunters, animal-wrestlers, musicians, snake
charmers, and dancers of many nationalities.

PALACES OF THE PERFORMING ARTS

Movie palaces, which in pre-television/video days were the "cathedrals, and temples, and crossroads of the world," were also the most universal of Art Deco structures. Sprouting in many cities across the globe, bringing Hollywood fantasies to all, the style of these theaters was lavish in the twenties and more streamlined in the thirties. Many places of amusement, casinos, dance halls, theaters, swimming pools, zoos, and museums were also built with Art Deco designs. And

the overall style, having originated with an exposition itself, seemed created to promote and reflect the entertainment value of such places.

A fine example of movie palace Art Deco is the Paramount Theater in Oakland, California, designed by Timothy Pflueger for Miller & Pflueger and built in 1931. The striking facade of the Paramount is decorated with a tile mural of two enormous puppeteers who hold the strings of a colorful grouping of figures and animals involved in all manner of activities, from boxing and tennis to hunting, dancing, and merrymaking. Inspired by the enormous figures on one of the gates of the Paris 1925 Exposition, these puppeteers are rendered in a stylized fashion ornamented with stars, zigzags, and flowers. The towering murals flank an equally tall neon sign that spells out "Paramount" in simple block letters. The interior of the Paramount is also splendid. The lobby glows with recessed lighting concealed behind elegant pillars and a back-lit ceiling, while a procession of metal dancers parades along the top of a black and silver ledge. The ornate metalwork of a balcony and the intricate geometric pattern of the galvanized sheet metal ceiling overlook the monumental interior space, while the jazzy letters above the door spell out the optimistic self-promotional phrase "Always the best show in town." In the auditorium, every available square inch is decorated with some type of stylized geometric or figural ornament, from

the faceted sheet metal ceiling to the wall panels and grilles that flank the stage area.

Another urban showpiece, New York City's Radio City Music Hall, is part of the massive office, entertainment, and retail complex of Rockefeller Center. Radio City was built in 1932, with Edward Durrell Stone as the design architect and Donald Deskey as the interior design coordinator. The lobby displays an ele-gant Deco style that is apparent throughout the interior, from lighting and wall decorations to rugs and fabrics. The exterior is decorated with three polychrome oval medallions showing allegorical reliefs of the figures of song, dance, and drama, while the bronze doors to the auditorium feature vignettes of dancers with an international flavor by René Chambellan, and includes such subjects at the famous Rockettes and

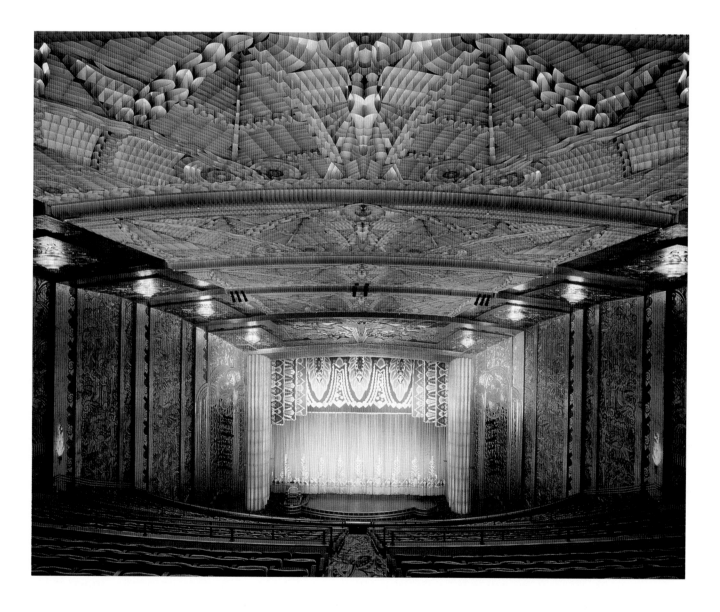

Auditorium of the Paramount Theater

Timothy Pflueger, 1931. Oakland, California.

Molded, galvanized sheet metal is used to create a dazzling faceted ceiling in this posh theater where every square inch of space has been ornamented in the Art Deco style. The fantasies of the movies are perpetuated by the lavish architecture, which virtually envelopes patrons in its splendor.

their leg-kicking chorus line, a German accordion player, a Jewish vaudeville act, and Egyptian dancers.

Many smaller and less ornate examples of Art Deco movie theaters also survive, such as the Orinda Theater (1941), in Orinda, California, designed by Alexander Aimwell Cantin, another San Francisco Bay Area architect, and inspired in part by buildings of the 1939 Golden Gate Exposition. The prominent neon sign of the Orinda Theater, as with many later Art Deco theaters, is an integral part of the building.

In fact, it is sometimes hard to believe that neon, which is such a part of modern life, was only discovered in 1898, and was first used as decorative lighting (enclosed in glass tubes and bombarded by electricity to create glowing colors), in 1919. Indeed, neon—

originally used to light the Paris Opera House in orange and blue—only made its appearance in the United States in Los Angeles in 1923 and, not surprisingly, continues to owe many of its stylistic conventions to the Art Deco period. Neon signs were initially added to buildings such as hotels or movie marquees to give them a modern look, but by the 1930s neon was being utilized as an integral part of building design.

COMMERCIAL BUILDINGS AND PRIVATE RESIDENCES

Many places of business, from commercial buildings to corporate headquarters, were designed with Art Deco methods and materials. The Old Oakland Floral

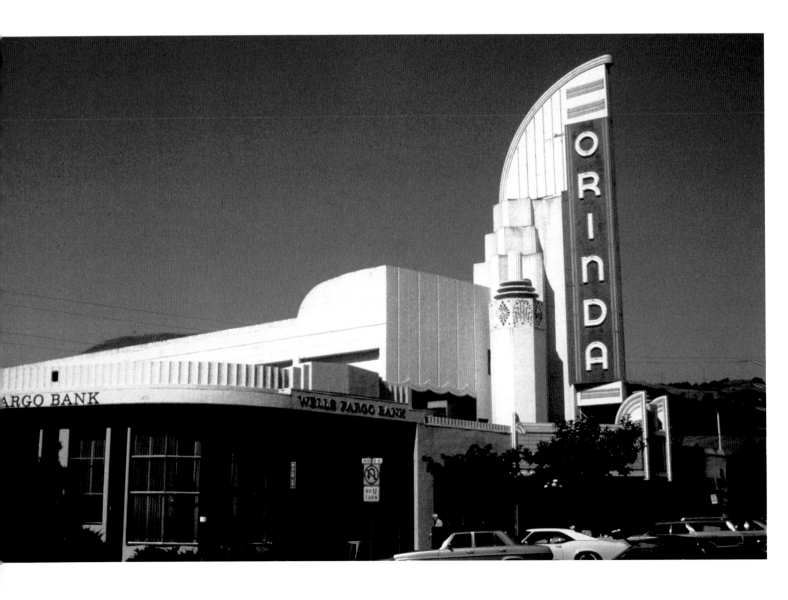

Depot on Telegraph Avenue in San Francisco (designed by Albert J. Evers) is a fine example of the use of terra-cotta in an Art Deco structure. The facade is made handsome by the use of terra-cotta ceramic tiles, some glazed a deep navy-blue and some a bright silver, molded into ornate decorations inspired by the headdresses of the ancient Mayans, zigzags, chevrons, and other geometric shapes. The Shell Building in downtown San Francisco (designed by George Kelham) has a monumental arched entrance several stories high that frames a glass and metal grille highlighting a shell design and a complementary arch motif.

Another fine example of Art Deco is the Niagara Mohawk Power Corporation Building in upstate New York (designed by Bley & Lyman), which incorpo-

Old Oakland Floral Depot

ALBERT J. EVERS, 1931; terra-cotta facade in navy-blue and silver. 1900–32 Telegraph Avenue, San Francisco, California. Molded into the elaborate forms of Mayan headdresses, terra-cotta creates drama on the facade of this unusual commercial building. The contrast of navy-blue and silver glazes, the rhythm of repeated geometric forms, and the crowning spire all enhance the visual appeal.

Orinda Theater

ALEXANDER AIMWELL CANTIN, 1941. Orinda, California.

The neon sign is an integral part of the design of this elegant movie theater which drew inspiration from the buildings of the Golden Gate International Exposition. Both monumental and streamlined, the vertical sign imbedded in a curved pier rises to become a prominent feature of the urban landscape.

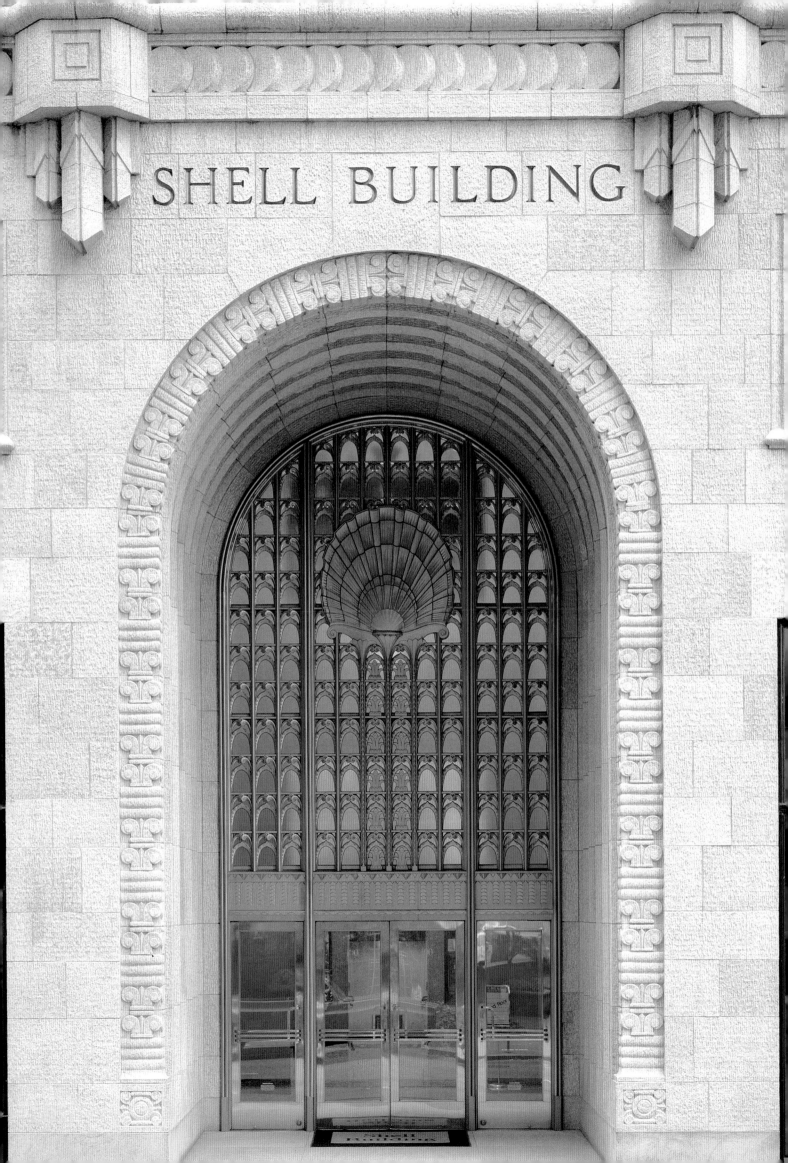

SHELL BUILDING

rates the gleam of stainless steel into its limestone facade. High over the entrance is a sculptured figure-head made of stainless steel, *The Spirit of Light* by Clayton Frye. There are also many fine examples of "Moderne" industrial buildings in England, such as the low whitewashed Hoover Factory (1932) in sub-urban London designed by Wallis, Gilbert and Partners, and the Firestone Building (1929) in Brentford, outside of London, which is built of reinforced concrete and decorated with exotic hybrid-style polychrome.

Relatively few private homes were built in the Deco style, as home buyers tended to favor more conserva-tive styles such as the imitation timbered look of mock Tudor and, later, the clean lines of the International style. Apartment buildings, however, acquired a fash-ionable modern look, with a variety of decorative Deco enhancements, often focused on entrances and lobbies, near windows, and around the tops of build-ings. Such decoration drew upon a multitude of sources—Mayan, Aztec, Greek, Native American, Persian, Spanish, and Egyptian motifs were all popu-lar. Parallel lines were used as accents, often grouped into threes and sometimes "pulvinated"—that is, puffed out from the flat surface with a convex shape, while columns were flattened to conform to the lines of facades. Colored glass inserts were added to give variety of texture and contrast of color, as well as translucency, while inside lobbies plaster was molded and painted in geometric designs. Innovative metal work and lighting also added punch to decorative schemes.

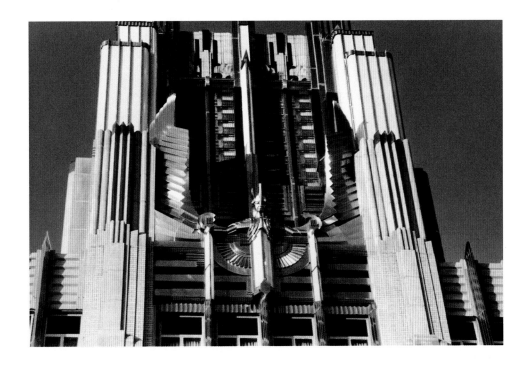

Spirit of Light

BLEY & LYMAN, architects, 1930–32; stainless steel sculpture by Clayton Frye on the front facade of the Niagara Mohawk Power Corporation Building in West Syracuse, New York. A gleaming metal figurehead suggesting a cross between Hermes (messenger of the Greek gods, as well as god of commerce), a Native American thunderbird, and an armor-clad warrior crowns the entrance of this limestone, brick, and metal structure. Full of optimism and distinc modern, the *Spirit of Light* fulfills a dramatic role as the public symbol of a power company in the machine age.

100 Bush Street—The "Shell Building"

GEORGE KELHAM, 1929. San Francisco, California.
A monumental entrance displaying a metalwork shell motif gives this building enduring appeal. The light colored terra-cotta facade set with bold relief ornament contrasts well with the glass and metal entryway.

Following page:

The Ethel and Raymond Worgelt Study

ALAVOINE, design, 1928–1930; from 575 Park Avenue, New York City. Gift of Raymond Worgelt, The Brooklyn Museum, New York.
A linear geometry of arches, parallel lines, and zigzags adorns this elegant period study. A built-in upholstered bench evokes the conveniences found on the great ocean liners of the period.

ART FOR A CHANGING WORLD

The often imposing nature of Art Deco lent itself well to monumental architecture. Eliel Saarinen's Alexander Hamilton Memorial Project is an example of a structure inspired by the 1925 Paris Exposition buildings. A preliminary design shows an open circular canopy supported by four square, fluted columns on a terraced base, the whole creating an impressive "frame" for the statue of Hamilton, an influential American statesman of the nation's colonial period.

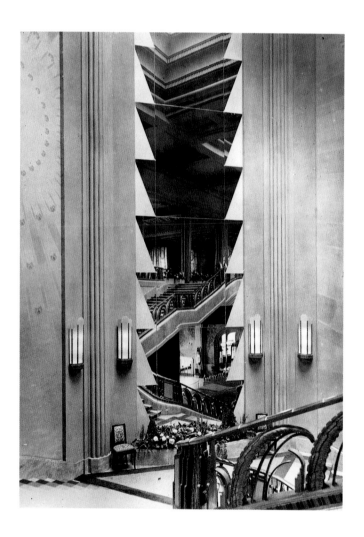

Grand Stairway at the Casino

Undated photograph, Nice, France.

This strikingly modernistic stairway once led to the great Baccarat Room of Frank Jay Gould's $5,000,000 "Palais de la Mediteranée" casino in Nice, France.

The relief sculpture or plaque was also a popular type of decoration during the Art Deco era. Themes varied, though usually an allegorical subject that related to the function of the building was chosen; thus a theater would have decorations on themes of comedy and tragedy, or drama and dance, while buildings such as the Associated Press Building at Rockefeller Center boasted a plaque above its entrance on the subject of news. *News*, by the Japanese-American sculptor, Isamu Noguchi, presents a typically optimistic and glorified view of the journalist's trade. A group of rugged, muscular men in shining stainless steel are shown making phone calls, taking notes, snapping pictures, and operating a printing press, while their gestures, combined with the dramatically receding lines of the telephone wires, give the impression of speed and purpose.

Optimism and a sense of the energy and purpose of modern life were on-going themes of the period—a type of visual propaganda to counteract the harsh realities of war, anti-Semitism, and economic hardship. Oskar Schlemmer painted the *Bauhaus Stairway* in 1932, portraying machinelike students moving within a stagelike setting, a year before the Nazis closed the influential design center and denounced its art as "degenerate" and a "hotbed of cultural Bolshevism."

Another Bauhaus painter, Lyonel Feininger, depicted *The Steamer "Odin" II* using the same fragmented planes of color and subdued reverence with which he painted cathedrals. Feininger, who returned to his native America in 1937, employed Cubist techniques to capture in his work a personal, crystalline vision. Feininger's choice of an ocean liner as his subject is in keeping with the popularity of such themes at that time. Ocean liners were not only a subject of art work but also another arena for the luxury and elegance of Art Deco decoration.

Bauhaus Stairway

Oskar Schlemmer, 1932; oil on canvas; 63¾ x 44¾ in. (161.9 x 113.6 cm).
Gift of Philip C. Johnson, The Museum of Modern Art, New York.
The figures seem mechanical or mannequinlike in this painting of students climbing upstairs at the Bauhaus, an influential design school in Germany. Schlemmer was also interested in theater design, and would often arrange the people in his paintings as if they were on a stage set.

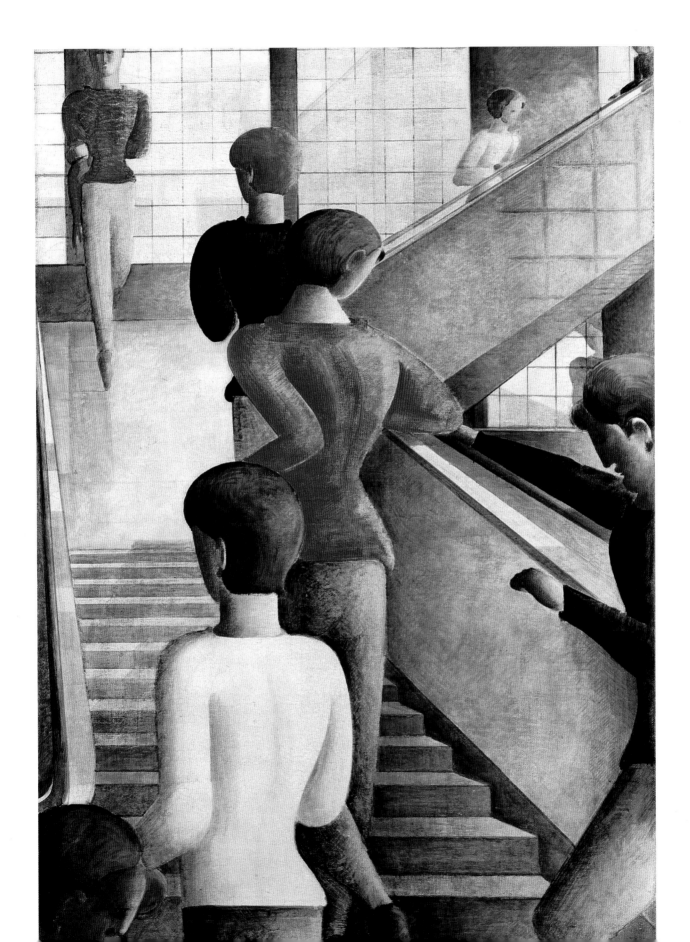

MARE TRANSIVIT

RAYMOND DELAMARRE

Panel in the Dining Salon, Interior of the *Normandie*

1937, The Byron Collection, Museum of the City of New York. Ocean liners were prime candidates for Art Deco decoration, which gave a posh elegance to their interior design. Shown here is the panel from the dining salon, starboard side forward, cabin class, of the French Line's great Deco

The *Orion*, built in England in 1935, had the distinction of being the first Art Deco Pacific Liner. It plied the waters between England and Australia for the P&O Line's Orient Line fleet. Specially designed furnishings for the *Orion* included horse-shoe chairs and engraved mirrors, including one (by British designer E. McKnight Kauffer) etched into a design depicting the ship's namesake, the constellation Orion. Kauffer's design is linear and elegant—with a classic Deco aesthetic that enhances the atmosphere in the ship's restaurant. Walter von Nessen's "diplomat" model coffee service would have been right at home in that dining room. The simple lines of the fluted chromium-plated copper coffee pot, creamer, and sugar bowl are accented with black plastic handles that suggest the look of ebony.

Travel is also the theme of Georges Lepape's 1925 cover for *Vogue*, which shows a female model in Sonia Delaunay's zigzag-accented "optical dress" with the up-to-date addition of a motoring helmet and goggles. Leaning on her powerful looking car, which sports a prominent winged hood ornament while a compass hovers in the sky, this woman sums up the optimism of the age: women's changing roles in society, the triumph of the automobile, a love of speed, the glamour of travel, and the jazzy geometry of new fashions.

The Steamer *Odin*, II

LYONEL FEININGER, 1927; oil on canvas; 26 x 39 in. (66 x 99 cm). Acquired through the Lillie P. Bliss Bequest, The Museum of Modern Art, New York.

Feininger experimented with a very personal version of Cubism in which human figures become mere punctuation among the fragmented planes of man-made structures. A cool crystalline light pervades his canvases, giving them an ethereal and poetic quality.

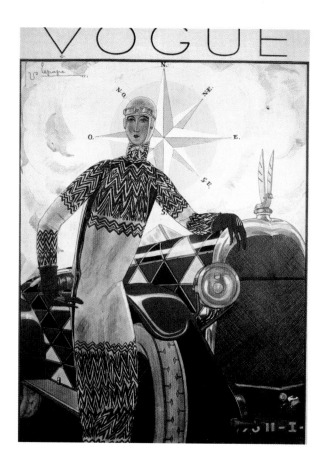

Vogue—Optical Dress by Sonia Delaunay

GEORGES LEPAPE, *midwinter travel number, 1925.*

A woman sporting a helmet and goggles, and attired in a
startling zigzag-covered dress designed by an innovative
French artist, casually leans on her gleaming roadster
in a memorable image that is part reality and part fantasy.

"Diplomat" Coffee Service

WALTER VON NESSEN, *before 1931; chromium-plated
copper and plastic; pot, sugar bowl, creamer, and tray.*
Stephen Carlton Clark, B.A. 1903 Fund (1982.30 A-D),
Yale University Art Gallery, New Haven, Connecticut.
All the pieces of this coffee service are made from a single
piece of chromium-plated fluted pipe. The handles are of
black plastic, a material considered a novelty at the time; the
effect evokes the luxuriousness of ebony combined with silver.

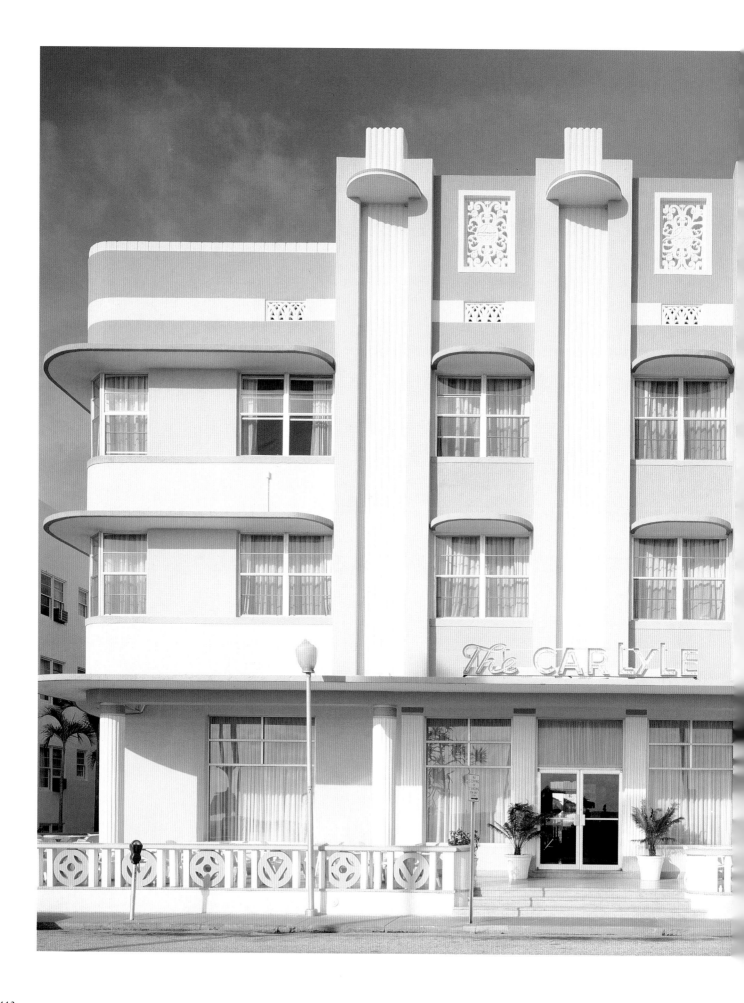

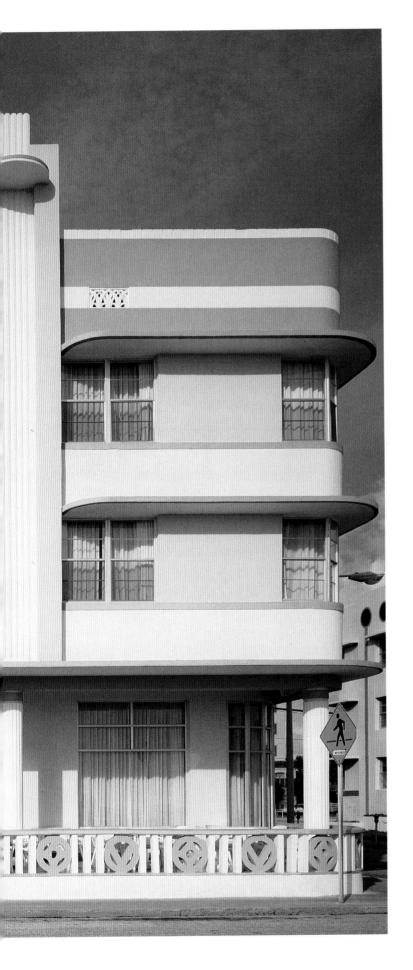

GRAND HOTELS

With the development of commercial airlines in the 1920s, the world suddenly became a smaller place. To accommodate travelers, hotels in the Art Deco style were built in many countries, ranging from minimally decorated to grandly ornate. The Strand Palace Hotel in London is one of the grandest, its entrance and lobby decorated with a linear, geometric style, a type of Art Deco known as Zigzag Moderne. There are also many Art Deco hotels in Old Miami Beach, Florida—such as the Plymouth Hotel (1940) and The Carlyle (1941)—an area which has undergone a revitalization since the mid 1980s thanks to the efforts of the Miami Design Preservation League.

The style of these Old Miami Beach hotels, which were mainly built in the thirties, has many of the familiar characteristics of other Art Deco buildings—combinations of flat and curved walls, glass blocks, monumental entrances, stepped profiles, pulvinated speed lines, racing stripes, counterpoint of vertical and horizontal elements, metal railings—but the types of ornament and details used often have a tropical flavor in keeping with the resort feeling of the Florida coast. Nautical references, such as porthole-shaped windows and ship's-deck balconies, abound, while the pastel colors and reliefs of flamingoes, pelicans, and palm trees give these buildings a unique charm and sense of place. The design of the Plymouth Hotel derives its drama mainly from the Egyptian obelisk tower that soars from the rounded entrance of its corner location. The Carlyle gets its charm from the contrast of flat and curved elements, its stepped roof line, clean lines, and smooth surfaces punctuated by ornate grilles, in addition to a wonderful paint job which brings out the vertical and horizontal contrasts.

The Carlyle, 1250 Ocean Drive

Kichnell & Elliott, 1941. Miami Beach, Florida.

A delightful palette of pastel colors enhances the Art Deco appearance of this hotel, which makes its statement with a stepped roofline, pulvinated speed lines, and curving "awnings" that are both functional and ornamental. The rhythmic alteration of flat areas with curves is further enhanced by paint.

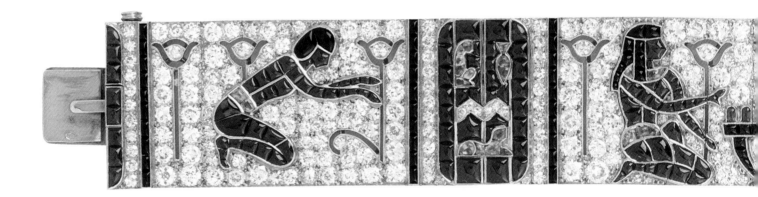

EVOKING THE ANCIENT AND THE EXOTIC

Art Deco designers excelled in the drive to create an illusion of luxury, whether in fantasy or in reality. If Deco architecture evokes a shipboard romance or a tropical paradise, Deco jewelry often makes reference to the wealth of the rulers of ancient civilizations. A bracelet by the firm of Van Cleef and Arpels, for example, draws its motifs from Pharaonic Egypt, and executes them in a glittering display of diamonds, sapphires, rubies, emeralds, and onyx mounted on platinum.

The wealth and power of ancient Egypt also are evoked in the entrance to the Circle Tower Building in Indianapolis. The monumental limestone arch and bronze grille are decorated with assorted motifs inspired by Egyptian art, from papyrus and lotus blossoms to scarab beetles and figures in ancient Egyptian dress. The decoration of 450 Sutter Street in San Francisco, on the other hand, evokes the art of the an-

cient Mayan civilization. Timothy Pflueger's design called for a beige terra-cotta exterior incised with a swirl of Mayan motifs; the tympanum ornament above the door recalls the exotic wealth of Mayan gold and an exterior detail reveals a copy of a Mayan mask with its characteristically squarish spiral eyes. The lobby, which includes an unusual stepped arch ceiling, contrasts dark marble walls with panels of flat ornament. If the decorative aspect seems a little overdone, that was part of the drama of the Art Deco style, which at times achieved opulent theatricality by means of an almost romantic involvement with the ornament of the non-Western past.

A LASTING APPEAL

A popular and public style in its time, Art Deco has also proved its lasting appeal. Although there is no doubt that the unornamented and economical International style in many ways will remain the dominant architectural style of the century, recently archi-

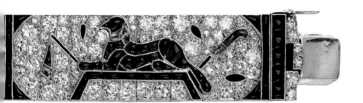

Two Bracelets with Egyptian Motif

Van Cleef & Arpels, c. 1925; diamonds, emeralds, sapphires, rubies, and calibré onyx mounted on platinum. Musée Van Cleef & Arpels, Paris. The uncovering of the wealth of King Tutankhamen's tomb in 1922 created a craze for things Egyptian. Here, animal and divine figures borrowed directly from ancient Egyptian art form appealing designs colored by sparkling gemstones.

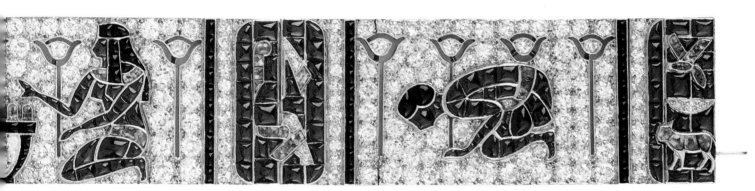

tects desiring a more symbolic impact have turned to the time-tested formulas of Art Deco, while designers continue to include Art Deco images and styles among their repertoire of design options. Michael Graves was perhaps the first contemporary architect to begin to revive the forms of Art Deco in the early 1980s with such projects as the Humana Building in Louisville, Kentucky, which makes use of the Art Deco style in both its exterior look and interior details, as well as the furnishings. Also of note is Helmut Jahn's evocation of the Chrysler Building in his design for One Liberty Place in Philadelphia (1986)—completing its reference to that splendid example of New York Art Deco architecture, even to its zigzag neon crown.

Nostalgic trends in design periodically revive Art Deco forms, in good measure because Art Deco remains effective in evoking the elegance, luxury, and excitement of an earlier time. Optimism, exoticism, fantasy, theater, and a belief in the human ability to conquer seemingly any environment combine to form a style with enduring appeal. Remarkably, this appeal has been sustained in an increasingly mechanized society. Familiarity has taken the machine from its pedestal, and cars are thought more frequently of in terms of how many pounds of pollutants they produce rather than as emblems of progress, while airplanes are today an ordinary means of transportation and trains and steamships are believed somewhat quaint.

Yet when advertisers seek to capture public interest, invariably they rely on the inherent "sexiness of speed"—and the association of pretty women and fast cars to command attention. These methods still succeed in their purpose. The dramatic nature of the Art Deco style maintains a capacity to excite and attract, imparting a shining Hollywood aura to all it touches, and, as long as contemporary culture retains the cultural myths and icons that were born on the silver screen and in the heyday of modernism, Art Deco will continue to hold that power.

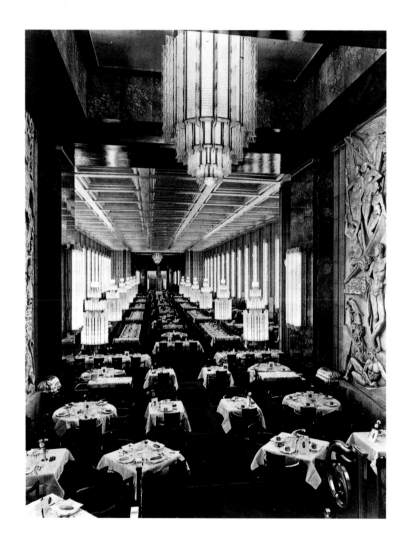

**Dining Salon
of the *Normandie***

*1937, The Byron Collection,
Museum of the City of New York.*
The romance and elegance
of ocean travel can easily be
imagined in this archival
photograph of the dining
salon of the French Line's
celebrated *Normandie*.

Brooch of Ivory and Coral

Georges Fouquet, c. 1923. Musée des Arts Décoratifs, Paris.
The bold forms of this brooch make reference to non-Western
traditions in adornment—perhaps the arts of Africa, which
were receiving a great deal of exposure in Paris at this time.
Bright colors and the use of ivory are characteristic of the period.

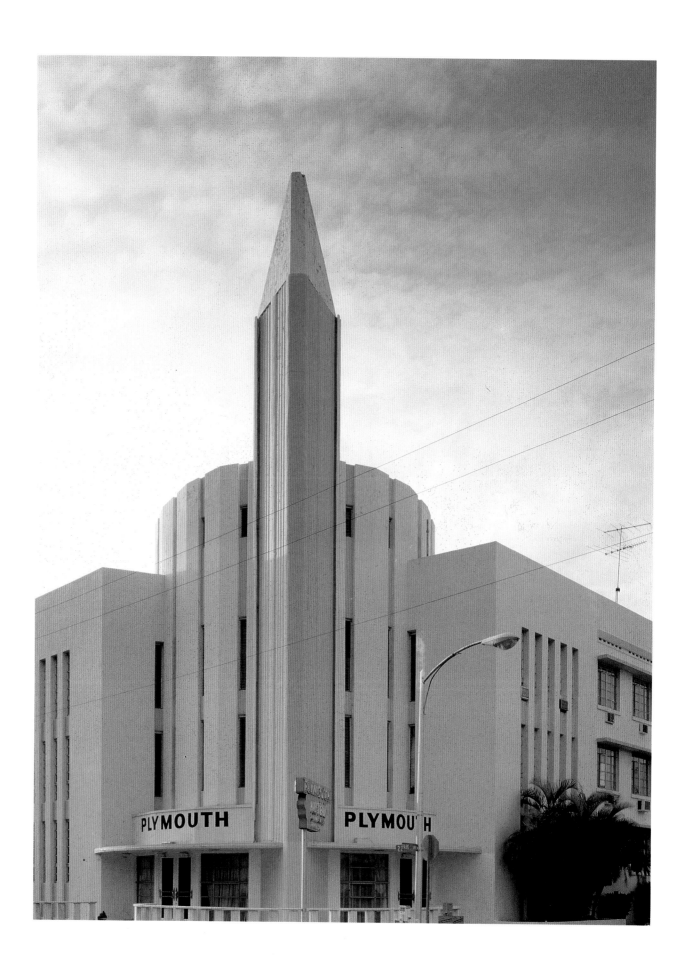

The Ziegfeld Theater

JOSEPH M. URBAN and THOMAS LAMB, 1929.
Photographed here in 1931, the great Ziegfeld Theater at Sixth Avenue and 54th Street in New York still displays the elegance and monument- ality of the Deco period.

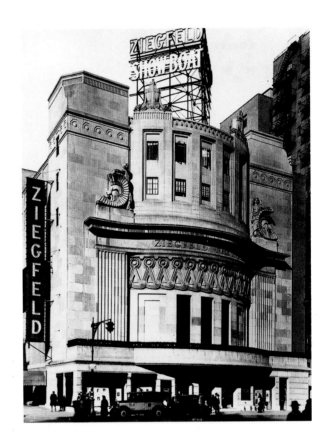

The Plymouth Hotel, 336 21st Street

ANTON SKISLEWICZ, 1940. Miami Beach, Florida.
A corner location inspired the architect in this handsome resort hotel that relies on the obelisk peak of its soaring tower to draw the eye and excite interest. A curving entrance steps down into two conventional blocks of rooms. Narrow windows in the central portion also create an illusion of increased height.

Alexander Hamilton
Memorial Project, Chicago

ELIEL SAARINEN, 1932–37;
perspective 1932; pencil and watercolor
on paper; 18 x 22 in. (45.7 x 55.8 cm).
The Art Institute of Chicago.
This lighted gilded bronze crown
supported by four enormous columns
was designed to display a statue of
Alexander Hamilton in a dramatic
and formal setting. The fluting of the
columns and the crown have a classical
feel—the total effect is monumental.

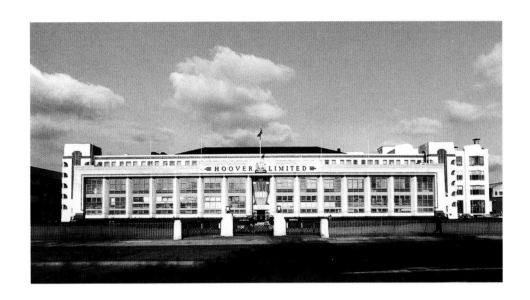

Hoover Ltd Factory

WALLIS GILBERT AND PARTNERS, architects, 1932. London.
This sleek whitewashed building is a splendid example of English industrial
Art Deco architecture. The low functional shape of the structure is
enhanced by polychrome detailing and a colossal front entryway.

1360 Montgomery Street

S. W. GOLDSTEIN, 1936. San Francisco, California.
The decorative drama of glass—a mural of sandblasted glass
portraying a leaping antelope in an abstract landscape—as well
as an elevator shaft of glass blocks give lightness and grace to
this apartment building. Note the wavy grilles on the ground
floor windows, echoed by the wave motif in the antelope mural.

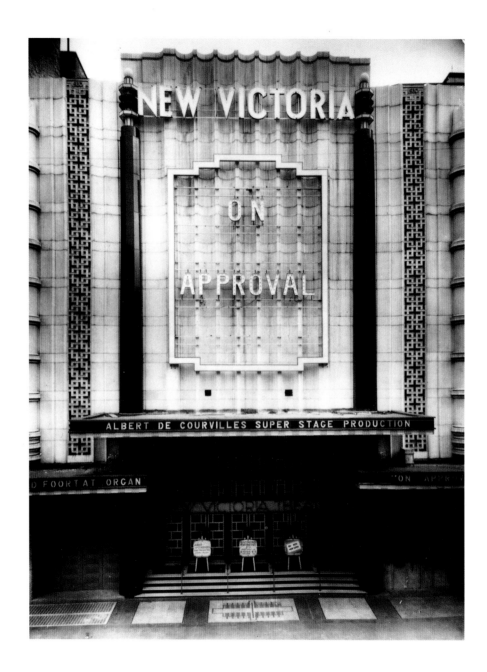

Facade of the New Victoria Cinema

E. WAMSLEY-LEWIS, architect, 1930. London.

The striking facade of this Art Deco movie theater is dramatized by
the strong contrast of its vertical and horizontal elements. The stepped
profile of the roof and also of the front marquees is typically Deco.

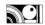

Stairway of the New Victoria Cinema

E. WAMSLEY-LEWIS, 1930. London.

Elegance is the rule for this broad stairway, the bottom railings of which are
ornamented with figureheads. A scalloped or fishscale motif is carried throughout
the decor—in the rug, the ceiling fixture, above the doorway, and into the upper level.

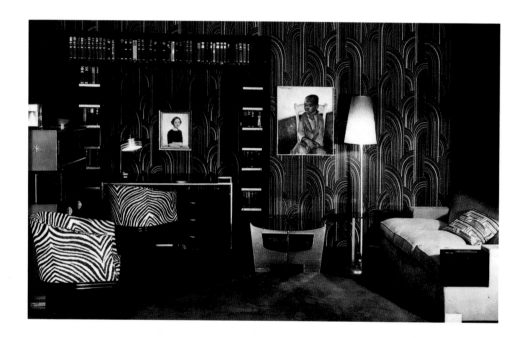

Art Deco Living Room

This Art Deco living room, complete with furniture and
wallpaper, displays the fruit of the mass-produced Deco accessories
which became available to ordinary apartment dwellers of the time.

Entry Lobby, 450 Sutter Street,

TIMOTHY PFLUEGER, 1928. San Francisco, California.
The architecture and ornament of the ancient Mayan
civilization were Pflueger's inspiration for the elaborate
lobby of this building. The Mayan motif is carried into the
exterior motifs and the detail on the elaborate tympanum
above the door as well as the incised terra-cotta facade.

INDEX

Page numbers in **boldface** type indicate photo captions.